The Crisis of
Criticism

The Crisis of Criticism

Edited by
Maurice Berger

THE NEW PRESS

NEW YORK

The publisher is grateful for permission to reprint the
following copyrighted material:

Homi Bhabha's "Dance This Diss Around." Originally published
in *Artforum*, April 1995, pp. 19–20.

An amended version of Michael Brenson's "Resisting the Danger-
ous Journey: The Crisis of Journalistic Criticism" was published by
the Andy Warhol Foundation for the Arts, Paper Series on the Arts,
Culture, and Society, Paper Number 4, April 1995. 1995 © Michael
Brenson.

Arlene Croce's "Discussing the Undiscussable." Reprinted by per-
mission of the author. Originally published in *The New Yorker*, De-
cember 26, 1994 – January 2, 1995.

bell hooks's "Making Movie Magic." 1996 © Routledge. Origi-
nally published in *Reel to Real: Race, Sex, and Class at the Movies* by
bell hooks, pp. 1–9.

Joyce Carol Oates's "Confronting Head-on the Face of the Af-
flicted." Copyright © 1995 by Joyce Carol Oates. Reprinted by per-
mission of John Hawkins & Associates, Inc.

Published in the United States by The New Press, New York
Distributed by W. W. Norton & Company, Inc., New York

Established in 1990 as a major alternative to the large commercial
publishing houses, The New Press is a nonprofit book publisher.
The Press is operated editorially in the public interest, rather
than for private gain; it is committed to publishing, in innovative
ways, works of educational, cultural, and community value that,
despite their intellectual merits, might not normally be
commercially viable. The New Press's editorial offices are
located at the City University of New York.

Printed in the United States of America

9 8 7 6 5 4 3 2 1

Contents

Acknowledgments

I would like to thank Dawn Davis, formerly of The New Press, for suggesting the idea of this book to me and for her astute ideas, editorial direction, spirit, and sensitivity. Grace Farrell has been an exemplary editor: her careful attention to the details of this project, her ideas about its shape and form, and her editorial comments have been most helpful. I should also like to thank Marvin Heiferman, Mason Klein, Therese Lichtenstein, and André Schiffrin for their generous advice and support.

M.B.

Introduction:
The Crisis of Criticism

Maurice Berger

In December 1995, the *New Yorker* published an impudent and startling piece of criticism—"Discussing the Undiscussable"—written by the esteemed dance critic Arlene Croce. The essay, ostensibly a response to a work by the black, gay, and HIV-positive choreographer Bill T. Jones that had recently premiered at the Brooklyn Academy of Music, made its extraordinary position clear at the outset: "I have not seen . . . 'Still/Here,'" Croce wrote unapologetically of the dance piece, "and I have no plans to review it."

Croce's principal objection to "Still/Here" was that Jones integrated into his performance video- and audiotapes of "real" people with cancer and AIDS. According to Croce, the presence of terminally or gravely ill people who were neither dancers nor dancing rendered the piece "beyond criticism"—a prime example of "victim art" that possessed a "deadly power over the human conscience." "Still/Here," she be-

lieved, wreaked of the kind of aesthetic "pathology" bent on manipulating an audience into feelings of sympathy, pity, and intimidation. Croce found such art entirely undiscussable because it "forced" the audience to feel sorry for its characters, who insisted on presenting themselves as "dissed blacks, abused women, or disenfranchised homosexuals." By the end of her essay, Croce lashed out at all forms of "issue-oriented" art (including the "grisly" Holocaust film *Schindler's List*) and lamented the way "community outreach," "multiculturalism," "minority groups," and even the National Endowment for the Arts were turning advanced culture into banal "utilitarian art" that was nothing more than "socially useful."

Croce's essay provoked a near-cataclysmic response: the *New Yorker* was flooded with letters, pro and con. Columns and letters appeared in magazines and newspapers across the country. College professors assigned the piece and its responses to their classes. While many in the right-wing press, such as Hilton Kramer, saw Croce's essay as a welcome retreat from the usual bias of "the mainstream liberal press by a critic with unimpeachable liberal credentials,"* progressive critics saw the piece as a regrettable attack on art that explores identity, adversity, or survival. Joyce Carol Oates, for example, citing such masterpieces as Dostoyevsky's *House of the Dead*, the American slave

*Hilton Kramer, "Notes and Comments," *The New Criterion*, 13, no. 6. February 1995, p. 3.

narratives of Frederick Douglass and Harriet Jacobs, and *The Diary of Anne Frank*, argued that "Still/Here," rather than pathetic victim art, exemplified "the long and honorable tradition of art that 'bears witness' to human suffering." Homi Bhabha wondered whether Croce's real concern was not the turning of illness into art, but, rather, the need to fire her own regressive, anti-multiculturalist salvo into the culture wars. How could Croce launch an attack on the "politicization" of art while writing an argument that was so unrepentantly political?

The story of Croce's essay and its spirited response represent an accurate microcosm of the debate around the role of identity politics in contemporary culture. In retrospect, however, they tell us even more about the perilous state of criticism itself. Oates, at the end of her essay, sees Croce's unwillingness to face the work she is writing about as an ominous sign of criticism's exhaustion:

> Criticism is itself an art form, and like all art forms it must evolve, or atrophy and die. There can be, despite the conservative battle cry of "standards," no criticism for all time, nor even for much time. Ms. Croce's *cri du coeur* may be a landmark admission of the bankruptcy of the old critical vocabulary, confronted with ever-new and evolving forms of art.

If Croce's audacious act raises questions about the ability of the critic to keep up with radical cultural

transitions, it also suggests an ironic twist. While Croce chooses to banish from her field of vision the work she purports to discuss, most Americans would appear to be more comfortable banishing the critic. It is now the critic who is often expendable in the process of determining what is good art and what is bad art. If earlier in this century, critics—journalistic, specialized, or academic—have frequently played a vital, even public, role in influencing the shape, texture, and direction of American culture, their value and relevance is growing increasingly tenuous in many sectors of mainstream American cultural life.

It is not surprising that the critic has lost his or her aura of respect. Everyone fancies him- or herself a critic. Ministers and politicians dismiss the photographs of Robert Mapplethorpe as bad art. A presidential candidate cites *Independence Day* as an example of outstanding, wholesome American filmmaking. Teenagers gush over Marilyn Manson, REM, and countless other rock groups on their home pages. This is not to say that the lay "critic" is always wrongheaded or shallow or, conversely, that his professional counterpart is always insightful. Nor, of course, are professional critics completely irrelevant to American culture. To one extent or another, certain vantage points afford professional critics the power to influence the relative success or failure of a given work, program, collection, or performance. An unfavorable review in the *New York Times* can close a Broadway play overnight; a negative spin on a fashion designer's

collection in *Women's Wear Daily* can turn away buyers as well as potential backers. Yet, even the most scathing notice in *TV Guide* will not stop the millions of viewers who either have not read the review or do not care about it from tuning in to an inferior television program.

Criticism is not, of course, a monolithic enterprise. Some journalistic critics function as industry cheerleaders; others insist on writing reasoned, analytical essays. Some critics write strictly for trade or specialized journals; others practice criticism as an academic discipline with defined methodologies. Sometimes the methodologies of one critical discipline cross over to those of another (for example, the influence of deconstructive and post-structuralist literary criticism on film and art criticism) or trickle-down from academia to the work of more mainstream writers.

Each critical discipline is governed by different histories, priorities, goals, audiences, and schedules—factors that can, in the end, effect the critic's ability to lead, follow, evaluate, or even recognize cultural trends. Academic journals, often directed at tiny, highly informed, and partisan audiences, may publish detailed analyzes of a given book, art exhibition, performance, or film well after it has disappeared from the market. Newspapers and popular magazines, for whom timeliness is a fact of economic life, demand that reviews be published concurrently or even prior to a work's premier. Classical music critics usually write about single concerts or recitals that may never

be repeated; film critics write about movies that will run for months. The audiences for the former are relatively small and are often wealthier, whiter, and older than the population at large; the audiences for the latter can soar into the millions, encompassing a vast cross-section of the population.

Despite these differences, the critic's voice rarely holds the central or estimable place it is accustomed to in most artistic disciplines and communities. Criticism, like the arts in general, is becoming more and more decentralized. The rising significance of community-based cultures, the increased targeting of niche markets, the dissolution of the boundaries between high and low culture, and the concomitant ethic and geographic diversity of audiences for culture have lessened and even delegitimized the need for dominant, centralized critical voices.

The profit-driven mentality of so much American culture has further affected the status and role of the critic. While the market has always influenced American culture, at no point has the role of interpretation and evaluation resided more in the hands of consumers as well as the institutions and companies that serve them. Indexes of consumer interest and satisfaction—measured not in critical praise but, rather, in sales records, gross receipts, top-ten lists, Nielsen ratings, and attendance figures—increasingly are the respected markers of cultural quality. Many critically acclaimed books, for example, end up as "failures" in the nickel-and-dime context of the mar-

ketplace. This problem arises, in part, from the increasingly short shelf-life of most books. The superstores that have put thousands of author-friendly independents out of business in recent years demand swift turnover and constant profitability. A "good" book, in the parlance of today's publishing world, is one that sells well and quickly. Recent trends in the world of avant-garde painting, sculpture, and photography suggest the extent to which money drives even the most esoteric cultural communities. In the fifties, sixties, and seventies, the careers of avant-garde visual artists were routinely made (and to a lesser extent broken) by critics and curators. However, by the time of the so-called art boom in the eighties, most of the hottest artists could attribute their success and even critical standing to the desires and support of a small coterie of powerful dealers and collectors.

This is not to say that market-based economies always sanction art that is unremarkable or simplistic. Americans are often discerning customers. The success of an outstanding television program such as *The Simpsons*—Matt Groening's profound and darkly funny look at the world of "family values" at the end of the American century—attests to the innate wisdom and sophistication of many television viewers. Yet, by diminishing the role of the informed critic in the evaluative process—in effect, making the end-user, the consumer, the most effective and persuasive arbiter of quality—market-driven culture leaves little room for minority points of view, edginess, difficulty,

or controversy, whether in the cultural mainstream or sometimes even at its increasingly embattled margins.

It is the critic, conventionally, who often supports or analyzes culture against the grain of popular tastes, indifference, or hostility. In the best of circumstances, the critic serves as a kind of aesthetic mentor, introducing an audience to challenging, little-known, or obscure works or offering insights that might make a work more accessible, engaging, profound, or relevant. The most incisive film critics, for example, do not just offer simple qualitative judgments ("thumbs-up," "thumbs-down") on the movies they evaluate; nor do they merely supply plot summarizes. Instead, they look for social, cultural, historical, or psychological meanings below the surface of the story. They are not just enthralled by cinema's illusions, but, as bell hooks observes about her own paradoxical relationship to the movies she writes about, question the way these illusions "seduce" and manipulate the viewer. And, in the end, the best film critics have the aesthetic sophistication, intellectual skills, and critical distance to champion and scrutinize the kinds of challenging films that the vast majority of the American movie-going population has no access to or ignores.

The academization of criticism—the growing inclination of many critics over the past thirty years to base their arguments on abstruse theoretical models—has also contributed to the marginalization of serious criticism. It is not theory per se that is the problem;

rather, it is the tendency of even the most experienced critics to slip into the jargon and mimic the style of the awkwardly written or translated treatises that influenced them. Critical writing—whether specialized or academic, on-line or in print—has all too often become bad writing. Many critical theorists reject writerly coherence as a matter of principle. Homi Bhabha, for example, argues that the very incoherence of certain theoretical texts can allow them to better represent the complexity of such difficult and involved concepts as power, identity, and paradox.* In other words, by exchanging lucidity and logic with elusiveness, such writing can more effectively demonstrate the contradictions and anxieties that motivate cultural artifacts and interactions.

There is no question that post-structuralist, psychoanalytical, feminist, and neo-Marxist theories have inspired new and radical forms of critical practice—by exchanging unexacting, naive, and fundamentally descriptive criticism for sophisticated arguments that offer new ways of looking at culture and of exposing the complex ideologies and myths that inflect every cultural artifact. Yet, if political analysis and persuasion is the goal of such criticism, the theoretical critic must begin to take a more realistic and

*See Bhabha, "The Commitment to Theory," in *The Location of Culture* (London and New York: Routledge, 1994), pp. 19–39.

informed look at the social and cultural scene he hopes to influence. The increasing adeptness of the radical right at political and cultural debate and the seepage of reactionary positions into the cultural mainstream (e.g., the recent liberal backlash against multiculturalism and identity politics) call into question the alienating obscurity of theory and the elitist provincialism of the academy.

Given these and other problems, how can serious criticism remain relevant or even desirable in a country where soundbites pass for erudite commentary, attention spans wane, and passion for the written word is becoming increasingly rare? Criticism must strive to be as resonant as the art it interprets, but without being abstruse or condescending. Sarah Rothenberg, writing in this book on the shifting relationship between critic and reader, recalls a time in the late nineteenth century when classical music criticism included excerpts of sheet music and complex exegeses. While such thoroughness would probably be excessive today, the best critical writing of our age remains *rigorous* and thoughtful. It aspires to something greater than the rewritten press releases that are frequently passed off as journalistic criticism. It reaches beyond the banal, narrow expositions of most "academic" literary critics—the kind of thinking, to quote Toni Morrison, "that is capable of . . . dismiss[ing] the difficult, arduous work writers do to make an art that becomes and remains part of and significant within a human land-

scape.* The strongest criticism today—the kind that offers the greatest hope for the vitality and future of the discipline—is capable of engaging, guiding, directing, and influencing culture, even stimulating new forms of practice and expression. The strongest criticism serves as a dynamic, *critical* force, rather than as an act of boosterism. The strongest criticism uses language and rhetoric not merely for descriptive or evaluative purposes but as means of inspiration, provocation, emotional connection, and experimentation.

The strongest criticism also helps the reader to move beyond the surface details of the cultural artifact. Art is neither value-free nor an independent source of values; to one extent or another, it always reflects the needs, politics, intellectual and aesthetic priorities, and tastes of the artist, the institutions that support and disseminate his or her work, and the social and cultural universe of which both are a part. By connecting the artifact and its institutions to the bigger picture of culture and society, the critic can, in effect, help readers better to understand the process and implications of art, the importance and problems of its institutions, and their relevance to their lives.

But many critics fail to understand their own purpose and responsibilities in the greater cultural and

*Toni Morrison, *Playing in the Dark: Whiteness and the Literary Imagination* (Cambridge, Mass.: Harvard University Press, 1992), p. 9.

social sphere. Two recent developments—the rise of politically motivated censorship and the defunding of the National Endowment for the Arts—have subjected the arts to an unusual degree of public scrutiny. Yet, as the art critic Michael Brenson observes, most journalistic critics have remained silent on these issues, refusing to take part in the very debates that have had the greatest implication for the future of art and artistic freedom in America. "If critics do not grab this . . . opportunity . . . their place in society will be lower," he observes solemnly. The lethargy of these writers exemplifies one of criticism's gravest problems: its tendency toward insularity and provincialism—a tendency that lowers the profile of art in society and affirms many Americans' belief that the arts have little or no relevance to their lives.

While at the end of "Discussing the Undiscussable" Arlene Croce argues that she cannot "remember a time when the critic has seemed more expendable than now," it is the artist and his wayward "political" agendas that she ultimately blames. If most of the other essays in this book tell us anything about the present-day crisis of criticism, it is that critics themselves can play a role in assuring that their voices remain audible to the disciplines they write about and to the audiences they write for. These essays advocate the kind of aesthetic and intellectual self-awareness usually associated with artistic practice; each in its own way argues that the critic, whether journalistic or academic, should be introspective and self-critical.

J. Hoberman, for example, laments the role assumed by most journalistic film critics as "underpaid cheerleaders." He wonders if the serious journalistic critic should not function more like a historian and provocateur—the "archivist," "bricoleur," "spoilsport," and "pundit" always positioned to shake up a film industry and an audience increasingly ignorant of cinema's past and disinterested in its future. Richard Martin espouses a fashion criticism that rejects a mindset of "vitiated objectivity and unquestioning enthusiasm" that is "accustomed to hyperbole and congratulation" in favor of a serious discipline with recourse to exacting critical models. Such criticism would not "jeopardize the energy and exuberance associated" with fashion, but, rather, should synthesize theories and complex ideas about clothes into smart, vivacious, writerly texts.

The field of academic criticism, according to Wayne Koestenbaum, is in need of similar reconstruction: the academic critic, rather than being committed to good writing and intellectual largesse, is all too often obsessed with professional status, vanity, and security. Many academics, he observes, write criticism not for the love of writing or the desire to explore new styles and situations, but to impress colleagues and tenure committees—a situation that has given rise to a spate of academic journals overflowing with dispirited, petty, and compromised writing. "I can only be excited," he writes, "by the prospect of the manifold forms—direct, ornate, guttural, crude, labyrinthine,

gnomic, interminable, minuscule—that [academic] critical endeavor might begin to take, when intellectual curiosity no longer has to take the form of obeisance and a grim-lipped, resigned pursuit of accreditation."

It is just such transformations in priority and tone that might once again make criticism indispensable. Pushing beyond the constraints of mere description or advocacy, the critic can aspire to *bliss*, to quote Roland Barthes—the kind of insightful and pleasurable writing that "breaks through the constraints of adjectives" to inspire, move, and incite the reader. Only then will the critic's voice rise above the din of mediocrity and compromise that too often passes as the best of American culture.*

*See Roland Barthes, *The Pleasure of the Text*, trans. Richard Miller (New York: Hill & Wang, 1975), p. 13.

Discussing the Undiscussable

Arlene Croce

I have not seen Bill T. Jones's "Still/Here" and have no plans to review it. In this piece, which was given locally at the Brooklyn Academy, Jones presents people (as he has in the past) who are terminally ill and talk about it. I understand that there is dancing going on during the talking, but of course no one goes to "Still/Here" for the dancing. People are asking whether Jones's type of theater is a new art form. Dying an art form? Why, yes, I suppose dying can be art in a screwily post-neo-Dada sense. (Dr. Kevorkian, now playing in Oregon . . .) But this is not the sense intended by Bill T. Jones, even though he had his origins as a choreographer in the Dada experimentation of the sixties. If I understand "Still/Here" correctly, and I think I do—the publicity has been deafening—it is a kind of messianic traveling medicine show, designed to do some good for sufferers of fatal illnesses, both those in the cast and those thou-

sands more who may be in the audience. If we ask
what a show does that no hospital, clinic, church, or
other kind of relief agency has so far been able to do,
I think the answer is obvious. If we consider that the
experience, open to the public as it is, may also be
intolerably voyeuristic, the remedy is also obvious:
Don't go. In not reviewing "Still/Here," I'm sparing
myself and my readers a bad time and, yet, I don't see
that I really have much choice.

A critic has three options: (1) to see and review; (2)
to see and not review; (3) not to see. A fourth
option—to write about what one has not seen—
becomes possible on strange occasions like "Still/
Here," from which one feels excluded by reason of its
express intentions, which are unintelligible as theater.
I don't deny that "Still/Here" may be of value in some
wholly other sphere of action, but it is as theater,
dance theater, that I would approach it. And my ap-
proach has been cut off. By working dying people into
his act, Jones is putting himself beyond the reach of
criticism. I think of him as literally undiscussable—
the most extreme case among the distressingly many
now representing themselves to the public not as art-
ists but as victims and martyrs.

In theater, one chooses what one will be. The cast
members of "Still/Here"—the sick people whom
Jones has signed up—have no choice other than to be
sick. The fact that they aren't there in person does not
mitigate the starkness of their condition. They are
there on videotape, the better to be seen and heard,

especially heard. They are the prime exhibits of a director-choreographer who has crossed the line between theater and reality—who thinks that victimhood in and of itself is sufficient to the creation of an art spectacle.

The thing that "Still/Here" makes immediately apparent, whether you see it or not, is that victimhood is a kind of mass delusion that has taken hold of previously responsible sectors of our culture. The preferred medium of victimhood—something that Jones acknowledges—is videotape (see TV at almost any hour of the day), but the cultivation of victimhood by institutions devoted to the care of art is a menace to all art forms, particularly performing art forms. In writing this piece, I enter a plea for the critic and risk being taken for a victim myself. But the critic is part of the audience for art that victimhood also threatens. I can't review someone I feel sorry for or hopeless about. As a dance critic, I've learned to avoid dancers with obvious problems—overweight dancers (not fat dancers; Jackie Gleason was fat and was a good dancer), old dancers, dancers with sickled feet, or dancers with physical deformities who appear nightly in roles requiring beauty of line. In quite another category of undiscussability are those dancers I'm *forced* to feel sorry for because of the way they present themselves: as dissed blacks, abused women, or disfranchised homosexuals—as performers, in short, who make out of victimhood victim art. I can live

with the flabby, the feeble, the scoliotic. But with the righteous I cannot function at all. The strategies of victim artists are proliferating marvelously at the moment. There's no doubt that the public likes to see victims, if only to patronize them with applause. The main type of victim art (the type that I think gave rise to all the others) is a politicized version of the blackmail that certain performers resort to, even great performers, like Chaplin in his more self-pitying moments. Instead of compassion, these performers induce, and even invite, a cozy kind of complicity. When a victim artist finds his or her public, a perfect, mutually manipulative union is formed which no critic may put asunder. Such an artist is Pina Bausch. Such an audience is the Brooklyn Academy's Next Wave subscription list, which also welcomed Bill T. Jones.

What Jones represents is something new in victim art—new and raw and deadly in its power over the human conscience. Jones's personal story does not concern me. But his story intersects vitally with cultural changes since the sixties that have formed an officialdom, a fortress of victim art. Bill T. Jones didn't do this all by himself; in fact, he probably didn't mean to do it at all.

Where it all began is not difficult to see. The arts bureaucracy in this country, which includes government and private funding agencies, has in recent years demonstrated a blatant bias for utilitarian art—art

that justifies the bureaucracy's existence by being so-cially useful. This bias is inherent in the nature of government, although it did not seem to be when I was on a National Endowment for the Arts panel in the late seventies. In those years, art and art apprecia-tion were unquestioned good things to support, and "community outreach" had its own program. Jones, who came along at that time, was one of our favorites, because he seemed to be uninterested in conforming to the stereotype of the respectable black choreogra-pher. By the late eighties, the ethos of community outreach had reached out and swallowed everything else; it was the only way the NEA could survive. The private funders soon knuckled under to the com-munity- and minority-minded lobbies—the whole dynamic of funding, which keeps the biggest govern-ment grants flowing on a matching-funds basis, made the knuckling-under inevitable. But ideology had something to do with this. When even museum di-rectors can talk about "using art" to meet this or that social need, you know that disinterested art has be-come anathema. (Disinterested art: you have to un-derstand that there's no such thing.) The ideological boosters of utilitarian art hark back to the political crusades of the sixties—against Vietnam, for civil rights. The sixties, in turn, harked back to the proletarian thirties, when big-government bureaucracy began. And now once again after a thirty-year lapse we are condemned to repeat history.

I'll say one thing for the sixties: the dance profes-

sion flourished in a climate of aesthetic freedom it hasn't enjoyed since. Jones's main connection to the sixties experimenters was to the power they'd claimed to control the terms on which they could be artists and be written about as artists. This, it turns out in retrospect, was their lasting legacy and Jones has been their most conspicuous legatee. Members of the sixties generation, seeing themselves as picking up where Merce Cunningham's revolution left off, had decided that walking and other forms of non-dance locomotion were in fact dancing. Their authority was John Cage more than it was Cunningham (who continued to use pure-dance movement), and for a few years there was lively controversy in New York over the direction of the new postmodern (as it was then not yet called) modern dance. It seemed to many that this kind of dance had a built-in resistance to criticism— not to writing but to criticism. There were critics who specialized in this art, or anti-art, but few of them went beyond description. They hardly ever wrote about conventional dancing, but then writing about conventional dancing is hard. It's easier to describe actions that can be "danced" by you and me and require no formal education.

Quite a number of the practitioners of the new dance assumed that because they abjured formality of expression they were beyond criticism—I don't know why. Dance critics have traditionally interested themselves in all sorts of "movement theater"—puppets, skating, the circus. Theoretically, I am ready to go to

anything—once. If it moves, I'm interested; if it moves to music, I'm in love. And if I'm turned off by what I see it's seldom because of the low-definition dance element. It was still possible in the sixties and seventies to unearth values in postmodern dance and write about those values as if they were the legitimate concern of the choreographers. Motion is motion; the body is the body. Multimedia theater, a big thing then, enforced its own disciplines; you could write about it. The concerts that Bill T. Jones gave with his partner, Arnie Zane, were different from the ones he gave after Zane's death, though both were fairly typical of the post-sixties atmosphere of "conceptual" dance. Talking and singing were mixed with dancing; dancing was mixed with nondancing. It was Jones who split the mixed media from the message, with his baiting of the audience. This was an aggressively personal extension of the defiant anticonventionalism of the sixties, when you were manipulated into accepting what you saw as art. With Jones, you were actually intimidated.

At first, I saw the intimidation as part of the game that postmodernists played. Choreographers as different as Kenneth King and David Gordon and, later, William Forsythe had fun heckling the critics—anticipating or satirizing the reviews. Jones also did this. When I blasted an early work of his with the phrase "fever swamps," he retaliated by using the phrase as the title of a piece. It wasn't long before the Jones company became openly inflammatory. Politically

provocative, accusatory, violent, it was a barely domesticated form of street theater. And it declared war on critics, the most vocal portion of the audience. Jones's message, like Forsythe's, was clear: No back talk! Anything you say not only will be held against you but may be converted into grist for further paranoid accusation.

Many writers who discovered dance in the sixties and seventies felt as if they'd stumbled into the golden age of the art. All the way up and down the line, the most wonderful dancing, the most brilliant choreography were all about dance. What happened to politicize it? The promotion, for one thing, of the new arts-support networks, which began to stress the democratic and egalitarian aspects of nonformal movement. Academics, teaching newly accredited dance history courses, also laid heavy stress on these aspects. By the eighties, when the culture wars got under way and the NEA was targeted by pressure groups left and right, it had become painfully clear that New York-centered, disinterested, movement-game, do-your-own-thing, idealistic postmodern dance was doomed. It was elitist. It had no audience. It produced no repertory. Most fatally, it did not establish itself in the universities and influence the coming generations. The sixties, it turned out, had been not the golden dawn but the twilight of American modern dance, and suddenly there was Pina Bausch and Butoh. And AIDS.

The kind of dance that was against criticism be-

cause it was "against interpretation" wound up a dependent of taxpayers who wanted a say in the art forms they were supporting. But didn't the problem really originate in the self-awarded privileges of the sixties radicals? The kind of "innovation" that seeks to relieve critics of their primary task of evaluation is always suspect. In the sixties, if you didn't like the rules you made your own; you fought the critics because they impinged on your freedom. In the eighties, you fought the critics because they hampered your chances of getting grants. Criticism had always been an issue in postmodern dance. I'm not sure that criticism wasn't *the* issue: the freedom of the audience to judge versus the freedom of the artist to create. In the visual arts, Warholism had pretty well demolished the need for serious criticism. And the same kind of trash-into-art transformations in dance tempted lesser talents than those who had thought them up in the first place. "It's art if I say it is," the Humpty-Dumpty war cry of the sixties, was a pathetic last-ditch attempt to confound the philistines, but now the philistines are likely to be the artists themselves. From the moment that Bill T. Jones declared himself HIV-positive and began making AIDS-focused pieces for himself and members of his company—from that moment it was obvious that the permissive thinking of the sixties was back, and in the most pernicious form. Actually, I'm not sure who came first: Jones the AIDS victim or Mapplethorpe the AIDS victim. But Jones and Mapplethorpe, parallel self-declared cases of pathology in

art, have effectively disarmed criticism. They're not so much above art as beyond it. The need for any further evaluation, formal or otherwise, has been discredited. Where will it go from here? If an artist paints a picture in his own blood, what does it matter if I think it's not a very good picture? If he mixes the blood with Day-Glo colors, who will criticize him? The artist is going to bleed to death, and that's it.

Painting pictures in their own blood was, metaphorically speaking, what many artists of the nineteenth century were doing. Even when they weren't mentally unsound or dying of syphilis or tuberculosis, they were preoccupied with death—their own or that of the Beloved. One's personal disease and impending death were unmentionable—Keats wrote no "Ode to Consumption"—but through art the individual spirit could override them both. Even in music, which can name nothing, which can only attract names (the Funeral March), and which can therefore speak freely, it is the surging spirit of Chopin that calls out, not the raging bacillus. One man, one death, one art. And what an art. After two world wars and the other unspeakable terrors of our century, death is no longer the nameless one; we have unmasked death. But we have also created an art with no power of transcendence, no way of assuring us that the grandeur of the individual spirit is more worth celebrating than the political clout of the group.

A few weeks ago, I attended a seminar on Schu-

mann and mental illness. The psychiatrists who spoke were unanimous in the conviction that though Schumann's ailments were clinically real and debilitating, they were not accountable for the generally perceived decline in his later music. Because Schumann went mad, we think the madness must have told in his art. But the later Schumann is not deranged; it is dry. The composer had exhausted himself in the rigors of his music. Drained of inspiration, he thought he heard themes being sung to him by angels, and they turned out to be variations on themes he had already composed. The depletion experienced by Schumann is haunting the world of art in which we live today. We are all, artists and nonartists alike, survivors and curators, shoring up the art of the past, rummaging among its discards for new ideas. The nineteenth century and its wealth of art almost can't be comprehended; the bravura individualism that drove Schumann on is almost alienating. Personal despondency is not so easily sublimated today, nor do we look to sublimate it. Instead, it's disease and death that are taking over and running the show. As in the old woodcuts of Famine and Plague, a collective nightmare descends from which no one may be spared. And the end of twentieth-century collectivism is the AIDS quilt. The wistful desire to commemorate is converted into a pathetic lumping together, the individual absorbed by the group, the group by the disease.

The morbidity of so much Romantic art is bearable because it has a spiritual dimension. The immolation

of the body leaves something behind: it's like a burning glass through which we see a life beyond life—not "the afterlife" but an animation of spirit, a dream life more abundantly strange and real than anything we know. The Romantics did not use art, they were used by it, consumed by it as much as by killer diseases. The mass-produced art of the twentieth century, art that has no spiritual dimension, is art that you can use. In fact, the potential of mass-produced art, whether for general enlightenment or gross dehumanization, was a prime topic of intellectual debate for most of the century. It wasn't so very long ago that people were arguing the merits of "educational" TV. They don't do that anymore. The last quarter of our century, which has seen the biggest technological advances in mass communications since the first quarter, hasn't sensitized us to the uses of mass-produced art; it has simply canonized as art that which is mass-produced. And it's the mass-production sensibility operating in terms of high art that's so depressing today—in these grisly high-minded movies like *Schindler's List* (showered with Oscars while the Serbian genocide went on and on), these AIDS epics, these performance-art shockers like "Still/Here." Artists today, whether their medium is popular art or not, work in a climate dominated by TV and the passive narcissism of the TV audience. The quasi-clinical attention to suffering that is the specialty of the TV talk shows may be a sham, but it's not such a sham as pretending to tell us how terminal illnesses are to be

borne or what to make of Schindler and his list. And can we really displace the blame for our cultural deprivation on the wars, the death camps, and the bomb? It's worth remembering that most of the masterpieces of art and literature of this century were created by exiles or by those who worked on despite evil conditions in their homeland.

And, despite everything that is being done to discourage them, good artists are at work today. *The Family Business*, a play written by David Gordon and his son Ain Gordon deals with sickness and dying in cathartic terms that are the polar opposite of those employed in "Still/Here." The main character, a helpless, ranting, shrewd old woman around whom the other characters form a death vigil, is played by David Gordon himself, in a housedress, with a foolish-looking barrette in his hair. There are no videos, no testimonials, no confessions, yet every word seems taken from life. How David Gordon, one of the original radicals of postmodern dance, escaped being trapped by the logic of sixties permissiveness and Bill T. Jones did not is a question that can't be answered by some presumed cultural advantage that Jews have over blacks. Jones, caught up in his own charisma, didn't seem to hear the trap being sprung. But there was also a more invidious logic at work, in the campaigns of the multiculturalists, the moral guardians, the minority groups. Together with entertainment-world evangelism and art-world philis-

tinism, they made up a juggernaut that probable no one in Jones's position could have escaped.

Bill T. Jones seems to have been designated by his time to become the John the Baptist of victim art. (His Christ was Arnie Zane, who died of AIDS in 1988.) For me, Jones is undiscussable, as I've said, because he has taken sanctuary among the unwell. Victim art defies criticism not only because we feel sorry for the victim but because we are cowed by art. A few years ago, a jury in Cincinnati acquitted a museum director who had been charged with obscenity for putting prints from Mapplethorpe's "X," "Y," and "Z" portfolios on public display. Members of the jury told reporters afterward that they had based their verdict on "expert" testimony that the photographs were art. Art sanctifies. The possibility that Mapplethorpe was a bad artist or that good art could be obscene seems not to have occurred to anyone. Naturally not, since this is a subject for critics to discuss, not juries.

I do not remember a time when the critic has seemed more expendable than now. Oscar Wilde wrote that the Greeks had no art critics because they were a nation of art critics. But the critic who wishes to restore the old connection between the artist and his audience appeals in vain to readers who have been brought up on the idea of art as something that's beneficial and arcane at the same time. People for whom art is too fine, too high, too educational, too complicated may find themselves turning with relief

to the new tribe of victim artists parading their wounds. They don't care whether it's an art form. They find something to respond to in the litany of pain, and they make their own connection to what the victim is saying. Of course, they are all co-religionists in the cult of Self. Only the narcissism of the nineties could put Self in place of Spirit and come up with a church service that sells out the Brooklyn Academy.

Confronting Head-on the Face of the Afflicted

Joyce Carol Oates

The very concept of "victim art" is an appalling one. Only a sensibility unwilling to attribute full humanity to persons who have suffered injury, illness, or injustice could have invented such a crude and reductive label.

There is a long and honorable tradition of art that "bears witness" to human suffering, but this is not "victim art" as the current term would have it, still less an art that manipulates or intimidates its audience to any perverse degree. (Doesn't all art, especially the conventional and pleasing, have the goal of affecting an audience's emotions?) That a human being has been "victimized" does not reduce his or her humanity but may in fact amplify it.

This issue, with its many political implications, has emerged in the maelstrom of response to an essay by the *New Yorker* magazine's veteran dance critic, Arlene Croce, on Bill T. Jones's dance "Still/Here."

"Discussing the Undiscussable" begins, "I have not seen Bill T. Jones's 'Still/Here' and have no plans to review it."

Ms. Croce's main objection was that "Still/Here" integrated videotapes and audiotapes of AIDS and cancer victims in a dramatic dance work, and that the presence of terminally ill "real" persons in the program rendered it, for her, "beyond criticism." It was, to her, a prime example of "victim art"—a "raw art . . . deadly in its power over the human conscience" and part of a larger "pathology in art" that seeks to manipulate audiences' feelings of sympathy, pity, intimidation, and terror.

By the end of her essay, Ms. Croce had lashed out indiscriminately at "issue-oriented" art (a thinly veiled slap at Tony Kushner's AIDS epic *Angels in America*) and all "mass-produced art of the twentieth century" (encompassing not only commercial television but the "grisly" Holocaust film, *Schindler's List*); she acknowledged her resentment at being "forced" to feel sorry for "dissed blacks, abused women [and] disfranchised homosexuals."

For her, this "pathology in art" began with the anarchic freedoms of the sixties' (anti-Vietnam War protest, blacks' and women's rights agitation) and flourished in the eighties, when hitherto marginalized ethnic-minority and gay Americans began to win grants from the National Endowment for the Arts and other institutions for their creative work.

From the start, Bill T. Jones was perceived as a threat, a radical black/gay artist who seemed peculiarly immune to harsh criticism from Establishment voices. ("When I blasted an early work of his with the phrase 'fevered swamps,' he retaliated by using the phrase as the title of a piece," Ms. Croce complained.)

Response to "Discussing the Undiscussable" was immediate and vociferous: an outpouring of letters, both pro and con; columns and editorials in the news magazines, the *Village Voice* and elsewhere, and a renewed, embittered debate between conservatives and liberals about the changing nature of art. As with the Mapplethorpe obscenity trial of several years ago, the article has raised crucial questions about aesthetics and morality, about the role of politics in art and about the role of the professional critic in assessing art that integrates "real" people and events in an aesthetic framework.

Why should authentic experience, in art, render it "beyond criticism"?

Consider great memoirist work like Dostoyevsky's *House of the Dead*, American slave narratives by ex-slaves like Frederick Douglass and Harriet Jacobs, the witness-bearing testimonies of the Holocaust survivors Primo Levi, Elie Wiesel, Aharon Appelfeld, and Tadeusz Borowski, and poetry by Nelly Sachs and Paul Celan among many others.

The Diary of Anne Frank, by the young Dutch Jew

who died in Bergen-Belsen in 1945, is hardly the docu-
ment of a mere victim, any more than the powerful
elegy "The Ship of Death," D. H. Lawrence's last
poem, written on his deathbed, is.

We have poems of psychic disintegration by Gerard
Manley Hopkins, Emily Dickinson, and Sylvia Plath
that are nonetheless poems of transfiguration. We
have certain of Dorothea Lange's photographs—
Damaged Child, for instance; Walker Evans's portraits
of tragically exhausted migrant workers; the strange,
isolated, painfully human subjects of Diane Arbus;
the Buchenwald photographs of Margaret Bourke-
White, who considered herself a witness, an emissary.
"To understand another human being you must gain
some insight into the conditions that made him what
he is," she said.

Consider the graphic depictions of the oppressed
by Goya and Hogarth and Käthe Kollwitz, the lyric
tenderness of Edvard Munch's *Sick Child* and *Spring*,
which depict the artist's dying young sister. There are
tortured self-portraits by Egon Schiele, Frida Kahlo,
Francis Bacon. There are heart-rendering powerful
works of drama—Eugene O'Neill's *Long Day's Journey
into Night*, Tennessee Williams's *Streetcar Named De-
sire*, Edward Albee's *Who's Afraid of Virginia Woolf?*,
Sam Shephard's *Buried Child*, Marsha Norman's
'Night, Mother, Scott McPherson's *Marvin's Room*,
among notable others, that deal with extremes of
emotional distress—but how imaginatively, and how
differently from one another!

Of recent dramatic works that use "real" material most effectively, Emily Mann's *Still Life* and *Execution of Justice* are exemplary and have had an obvious influence on Anna Deveare Smith's one-woman documentary-performances *Fires in the Mirror* and *Twilight: Los Angeles 1992*. Romulus Linney's *Two*, a play about the trial of Hitler's second-in-command Goebbels, incorporates film footage from Nazi extermination camps; once the "real" is experienced by the audience, the stage sophistry and devious charm of Goebbels are shattered.

What is particularly revealing in Ms. Croce's position is a revulsion for art with "power over the human conscience." But what is wrong with having a conscience, even if one is a professional critic? If art is too "raw" to be reviewed, shouldn't it be witnessed, in any case, as integral to cultural history? (Surely the critic cares for art even when it isn't for "review.")

The counterminings of tragedy are more subtle than those of comedy. It is an absurd expectation that in the face of suffering the afflicted should invariably "transcend" their fates. Sometimes, yes: Dostoyevsky, by his account, seems truly to have embraced his destiny and experienced a mystic oneness with God (in an epileptic's ecstasy?). But hardly Samuel Beckett, Primo Levi, or Tadeusz Borowski. Many of our human stories end not in triumph but in defeat. To demand that victimized persons transcend their pain

in order to make audiences feel good is another kind of tyranny.

To declare some works of art "nonart" presupposed a questionable authority. "It's art if I say it is," Humpty Dumpty declares in *Alice in Wonderland*, and while we're meant to laugh at his smugness, Alice's creator, Lewis Carroll, meant more than a joke.

Art is a mysterious efflorescence of the human spirit that seems not to have originated in a desire to please or placate critics. At the juncture of the communal and the individual, in ancient cultures, "art" sprang into being: the individual artist expressed the communal consciousness, usually of a "divinely" inspired nature. The scribes of the Hebrew Bible and the New Testament were extraordinary storytellers and gifted craftsmen of narrative, but their tales were presumed not to be of their own invention. The earliest visual artists may have been visionaries, but their visions were surely not private ones; their art is anonymous, for the concept of "individual" did not yet exist.

At the point at which the individual begins to detach himself from the collective, the artist begins to achieve what we call "identity"; art may still be in the service of the nation or the tribe, but it has the unmistakable stamp of personality on it, and may be highly original.

Consider Hieronymus Bosch, the late-fifteenth-century Belgian, and the remarkable paintings he set

beside conventional Christian-iconographic art of his era and earlier: how bold, how bizarre, how hallucinatory were Bosch's great altarpieces, *The Garden of Earthly Delights*, *The Hay Wagon*, *The Temptation of St. Anthony*, and *John the Baptist in the Desert*. If ever there was a brilliant "pathology of art," Bosch is our patron saint.

The exquisite mosaics and frescoes of the Byzantine-Roman world, in the service of an impersonal religious piety, blend together in their harmony (or blandness) once one has seen the eruption of sheer genius in a visionary like Bosch. Where was the critical intelligence that could have begun to assess Bosch in his time, let alone presume to prescribe his art?

The earliest sustained work of literary criticism in Western culture is Aristotle's *Poetics* (circa 335–322 B.C.), believed to be primarily a defense of tragedy and the epic as they were attacked by Plato in the *Republic*. Where Plato saw drama as disturbing and disruptive to the well-run state, and argued that the poet should be banished from it, Aristotle argued that literature's more profound effects were beneficent and purgative, and that the poet was a valuable citizen of the republic. The *Poetics* is a meticulously descriptive, not a prescriptive, work; Aristotle based his famous theory of catharsis on drama he had seen, works by Aeschylus, Sophocles, and Euripides. Twenty-three hundred years after it was written, the *Poetics* is arguably our greatest single work of aesthetics.

Yet out of this seminal work by one of the world's

great imaginative minds, there came to be, in subsequent centuries, as interpreted by less imaginative minds, a set of rigid rules meant to prescribe how drama must be written, else it is "not art." So Neo-classic dogma decreed that art insufficiently "Aristotelian" was not art. Even Voltaire, the inspired demolisher of others' delusions, rejected Shakespeare as barbaric because he did not conform to Neo-classic principles of unity.

The English critic Thomas Rhymer might have thought he'd wittily disposed of Shakespeare's *Othello* by calling it "much ado about a handkerchief." Samuel Johnson, the greatest critic of his time, felt obliged to reject such masterpieces as Milton's *Lycidas* and *Samson Agonistes* for violations of Neo-classical decorum. (Yet Johnson was not so blind as to reject Shakespeare, for whose genius he was willing to stretch Aristotle's principles, choosing to interpret Shakespeare's drama as something he could call a "mirror of life.") Nahum Tate, English poet laureate of the early eighteenth century, "corrected" the insufficiently uplifting ending of *King Lear*, providing Cordelia with both life and a husband, Kent; this popular stage version ran into the 1830s.

Through the centuries, through every innovation and upheaval in art, from the poetry of the early English Romantics to the "Beat" poetry of the American fifties, from the explosion of late-nineteenth-century European Modernist art to the Abstract

Expressionism of the mid-twentieth-century America, professional criticism has exerted a primarily conservative force, the gloomy wisdom of inertia, interpreting the new and startling in terms of the old and familiar; denouncing as "not art" what upsets cultural, moral, and political expectations. Why were there no critics capable of comprehending the superb poetry of John Keats, most of it written, incredibly, in his twenty-fourth year? There were not; the reviews Keats received were savage, and he was dead of tuberculosis at the age of twenty-five.

When, in 1862, Emily Dickinson sent several of her characteristic poems to one Thomas Wentworth Higginson, an *Atlantic Monthly* man of letters on the lookout for "new genius," her hopes were dashed by the smug sensibility of an era: Higginson was a traditionalist confronted by poetry as radical for its times as Cézanne's landscapes would have been in provincial New England. Is this, Higginson wondered, poetry at all? Imperfectly rhymed, its metrics spasmodic, punctuation eccentric. "Remarkable, though odd . . . too delicate—not strong enough to publish." Dickinson did not publish any of her 1,775 poems during her lifetime.

Walt Whitman's *Leaves of Grass*, privately printed in 1855, received only a few enthusiastic reviews—Whitman's pseudonymous own. Otherwise, poet and book were denounced—and would be for decades—as "obscene." So, too, Kate Chopin, whose elegantly written novel *The Awakening* brought her

arguably the most violent critical opprobrium ever endured by an American artist.

Our most beleaguered American Modernist writer, William Faulkner, long a target for jeering, uncomprehending reviews (his principal nemesis was the influential Clifton Fadiman, writing for the *New Yorker*, greeting one after another of Faulkner's great novels with unflagging and gleeful scorn) emerged at last to international acclaim and a Nobel Prize by way of the effort of French literary critics and the support of the American critic and man of letters Malcolm Cowley. Only after his canonization by the Nobel Prize did Faulkner begin to receive enthusiastic reviews here at home—though, of course, his finest work was long behind him.

When, in 1913, the Armory Show of European Modernist art came to the United States, there was an opportunity for American art and cultural critics to assess the new, innovative art that had swept Europe by storm. Instead, professional critics, like the general public, from Teddy Roosevelt on down, received the work of Gauguin, van Gogh, Cézanne, Matisse, Picasso, Braque, and Duchamp with cheerful derision.

Roosevelt publicly noted that Duchamp's *Nude Descending a Staircase* resembled a Navajo blanket; the most popular description of the painting was "an explosion in a shingle factory." Matisse's thirteen canvases drew the most savage reviews, and the artist had the honor of being hanged in effigy in Chicago, by

students at the presumably conservative Art Institute.

Of course, there have been exceptions to this dismaying history. An exemplary critic comes immediately to mind: Clement Greenberg, the early, for years the sole, critic championing the ridiculed work of Jackson Pollock. There was the intrepid Frank Budgen, preparing the critical groundwork for understanding James Joyce. One can name individuals here and there, but these are likely to have persisted in the face of their fellow critics' inclination for what is known, what is safe, what is "traditional."

One might expect, after so spotty a record, more hesitancy, more modesty on the part of critics. Yet the censorious-conservative impulse remains: to define art, to appropriate art, to "protect" art from apparent incursions of disorder, even by artists themselves.

If this is indeed an era, as Arlene Croce charged in "Discussing the Undiscussable," when critics seem "expendable," the news will not be greeted as a disaster in all quarters. Criticism is itself an art form, and like all art forms it must evolve, or atrophy and die. There can be, despite the conservative battle cry of "standards," no criticism for all time, nor even for much time. Ms. Croce's *cri du coeur* may be a landmark admission of the bankruptcy of the old critical vocabulary, confronted with ever-new and evolving forms of art.

Dance This Diss Around

Homi Bhabha

There would seem to be no reason in the world why Ameican readers should want to hear about Professor Harish Chandra, chairman of the Literature Department of the University of Pataniganj— a small cantonment town, 350 dusty, derelict miles from Bombay, where the oranges are sweeter than almost anywhere in India. But the kind of "connectivity" that comes with the entanglements of e-mail turns us all into vernacular cosmopolitans, and it is unwise, anymore, to presume we know where the center lies and where the periphery falls. And there is another reason: like the United States, the University of Pataniganj is involved in a culture war.

My electronic informant tells me that it all started, those many thousands of miles away, with a few lines from Sylvia Plath's "Lady Lazarus":

Dying
Is an art, like everything else.
I do it exceptionally well.

I do it so it feels like hell.
I do it so it feels real.
. . .

It's easy enough to do it in a cell.
It's easy enough to do it and stay put.
It's the theatrical

Comeback in broad day
. . .
That knocks me out.

It is the theatrical display of suicide that knocks out
Professor Chandra: "dying as an art," he argues, can-
not be the subject of critical study. By working her
suicide attempts into a poetic act, Plath violates the
critic's most fundamental requirement of the poet, the
"ideal of disinterestedness." That disinterestedness
can only operate when the artist transcends the nar-
cissism of self, when suffering, victimage, hurt, and
historical or personal trauma are purified in the up-
lifting, injury-immolating fire of Spirit.

Some of Chandra's colleagues have suggested that
Plath destroys any vestige of narcissism when she
moves from her own suicide attempts to the historical
trauma of unwilled mass death—to the Holocaust.

This idea leaves Chandra cold and furious, for he believes that the individual sovereignty of the spirit should not be obscured by the trials of history, however urgent they may be. For him, Plath represents victim art. In the name of the autonomy of art and the freedom of criticism, he has decided that Plath's poem will not be taught in the Pataniganj Literature Department; out of respect for the dead, deeply ingrained in his form of Hinduism, he will remain forever silent on her work.

Despite technology's hot rush, news that comes over the Internet can easily turn into nothing more than an exotic turn-of-the-twenty-first-century traveler's tale. Not this time: the debate on the art of dying that is playing itself out in the betel-juice-stained teashops of provincial Pataniganj quietly clarifies the afflatus set off by Arlene Croce's now-celebrated *New Yorker* essay, "Cussing the Undissable," sorry, "Discussing the Undiscussable."* Croce's *succés de scandale*, you'll remember, arose from her refusal to see Bill T. Jones' dance work "Still/Here" on the grounds that his use of HIV-positive dances, and of video testimony by AIDS patients, turned the art of dance into "victim art," a "traveling medicine show." The *scandale* lay in the fact that her refusal to see the show didn't stop her from writing about it. What Susan Sontag has

*Arlene Croce, "Discussing the Undiscussable." Originally published in the *New Yorker*, 26 December 1994/2 January 1995, pp. 54–60. Reprinted here, pp. 15–29.

described as the "storm of mostly self-serving responses to Croce's 'non-review'" is now overflowing the proverbial teacup, and every available empty vessel and shallow receptacle has been commissioned to catch the effluent.*

Pious pleas that Croce should have *seen* "Still/Here" before writing her piece entirely miss the radical point of her polemic. By creating a defiant hole at the very heart of her essay, in the space where, customarily, the experience or analysis of the work would have appeared, Croce makes it clear that hers is no simple act of critical interpretation and evaluation, nor even a meditation on those arts: it is a frankly ideological maneuver. If "Still/Here," present in her argument only as the spectral subject of controversy, prepublicity, rumor, and report, is by any standard an example of what Croce deplores as the use of art "to meet this or that social need," she in turn uses the work to make this or that political argument. For her, Jones's piece is the culminating achievement of the "ideological boosters of utilitarian art [who] hark back to the political crusades of the sixties"; it is the icon of the undiscussable, "dissed blacks, abused women, or disfranchised homosexuals"; it is a symptom of the death of the kind of aesthetic "disinterestedness" in which the "grandeur of the individual spirit" transcends "the political clout of the group."

*Susan Sontag, letter to the editor, *New York Times*, 26 February 1995, p. 3.

Despite Croce's plea for critical disinterestedness, there is no mistaking the interests of her argument, "Discussing the Undiscussable" is not simply a non-review of Bill T. Jones (*pace* Sontag); it is, as the author of an unsigned article in *The New Criterion* was quick to recognize, a particularly significant moment in the ideological battles of the culture wars. Never before, according to that journal, has such a critique of the "ideology of victim art" "been made so categorically in the mainstream liberal press by a critic with unimpeachable liberal credentials."* And *New Criterion* editor Hilton Kramer should know, for now that the Marxists have gone all postmodern, and the race and gender critics are fleeing their earlier essentialisms, there is no one left more pristinely ideological than he, following his *idées fixes* with the fervor of a truffle hound working the gourmet counters at Dean & Deluca.

What is at issue, I believe, is not the turning of illness or madness into art—a project with a long and famous history, elaborated by Joyce Carol Oates in a recent essay in the *New York Times*.† Nor can Croce really sustain her objection to putting HIV-positive performers on stage, in performance. To claim that

*"Notes and Comments," *The New Criterion* 13 no. 6, February 1995, p. 3.
†Joyce Carol Oates, "Confronting Head-on the Face of the Afflicted." Originally published in the *New York Times*, 19 February 1995, sec. 2, p. 1–23.

"Still/Here" represents a monstrous conflation of the existential condition of the person with AIDS and the aesthetic conventions that determine his or her "identity" as an actor in an AIDS-related performance is barely credible from a critic of such sophistication and experience. And to go on to suggest that the inevitable effect of such "victim art" is to solicit sympathy and collusion, rather than to invite a properly "disinterested" critical reading, is fatally to confuse the dancer with the dance. All acts of representation and performance require the willing suspension of disbelief; this is, paradoxically, at the very foundation of Croce's preferred critical criterion of disinterestedness. That criterion, I would have thought, particularly demands that we acknowledge the difference between the HIV-positive dancer as person and the HIV-positive persona as role, *especially when they inhabit the same body.*

Just as we are in danger of getting mired in the vicious circle of name-calling—the dissed victims versus the disdaining visionaries—the perspective from the orange groves of Pataniganj provides escape. Undistracted by the "bias for utilitarian art" of which Croce accuses the U.S. arts bureaucracy, undiverted by the presumption of cynical manipulation on the part of "minority" arts communities—"dissed blacks, abused women, or disfranchised homosexuals"— Professor Harish Chandra cuts to the bone of the issue. It is not that dying with dignity cannot enter art; pathology has its poetry, too. What troubles Chandra is Plath's theatrical, mocking, demotic dia-

logue with dying. Her use of the meter of the child's counting song and nursery rhyme "vernacularizes" the experience of both history and art, somehow "communalizes" the creative act. This is the quality of "Lady Lazarus" that has made the poem an icon for feminists and Holocaust survivors—to say nothing of thousands of poetry lovers—and, at the same time, has removed it from the possibility of cool critique.

The question is, I think, whether Plath's poem is a case of self-indulgent victimage or one of survival. Instead of celebrating Croce's "grandeur of the individual spirit" by releasing the art form vertically into a Platonic or Kantian sphere of aesthetic transcendence, Plath takes the survivor's experience of suffering and oppression—its shame, its destruction, its courage—and inserts it laterally into historical and aesthetic experience. As the verse moves among artistic registers and poetic techniques—from plainsong, through doggerel, to apocalyptic poetry—it translates its different social and psychic locations into a kind of communal relation. The poetic proximities Plath imagines are instructive rather than emotive or inflammatory: the living death of the failed suicide bears witness to the death in life of the gas chamber; the feminine scene of domestic violence is juxtaposed to the principles of public, political power. "Lady Lazarus" embodies not a simple *cri du coeur* of the kind Croce describes as a "cozy kind of complicity" but a spirit and technique of survival. At the same time, as biographers and critics have pointed out, the poem

focuses intensely on what Croce might call the "dissed and the abused" (Jews and women); it speaks specifically *from* and *of* a group.

Could it be that in identifying "Still/Here" as a narcissistic art of victimage, Croce may be missing the show's spectacular performance of survival—the attempt, as in Plath's poem, to counter the privacy and primacy of the individual self with the collective historical memory? I do not know; like Croce, I have not seen the work. Had I seen it, and had she, I could have written a different piece, a piece addressing Jones directly, rather than a piece about the uses and abuses of ideology—and ideology, roughly speaking, is about *what we think we see without really looking*. But where Croce left a blank, I have introduced an artwork that could be performed on the page—"Lady Lazarus"—in order briefly to talk of the metaphor of survival as a means of cultural and critical style.

If survival has no place in the aesthetics of transcendence, perhaps this is because it is a form of being that is somewhat undecided, ambivalent, about the dialectic of art and indeed the direction of life. To survive, technically, is to continue after the *cessation* of a thing, event, or process; to carry on in the light and shadow of a break, a trauma, a trial, a challenge. Survival demands a bridging, a negotiation, an articulation of the moments "before" and "after" without necessarily assuming a historical or temporal continuity between them. Survival also requires the courage

to live *through* the flux and transition of the moment of cessation.

If survival is predicated on a break in the structures of continuity—if the sense of identity, tradition, and myth has been subjected to cessation or seizure—then the notion of community or group identity (Croce's *bêtes noires*) becomes a crucial location for the dialogic practices of art, criticism, and culture. But, if sharing within the community allows for historical revision and the invention of tradition, then by that very token it must be remembered that our sense of community is an imagined and creative performance enacted across the double injunction of survival— *cessation and continuance*. To forget trauma is to be amoral and amnesiac; to remember trauma alone is to refuse to turn cessation into continuance, to resist the ethic and aesthetics of survival. What most disturbs Croce about "victim art" is its form as a collective representation, its articulation of art's "subject" as a group identity. She cannot envisage an art that would short-circuit the sublime, transcendent option to plug into a dialogue with a community that establishes its solidarity and group identity through sharing a desolate interruption, a cessation—death, mourning, melancholia. This is not a ruse to shortchange disinterested criticism, as Croce suggests. For emergent communities or the practitioners of new art forms, it is often a historical and psychic necessity to depend for their creative sustenance on a communal response

(often contestatory) from an "interest group" or interpretive community.

Perhaps the time has come for Croce to relinquish, even momentarily, the critical measure of "victimage" and give the language of survival a chance. Perhaps this is the moment for her to make her visit to "Still/Here." As for me, I shall repair via e-mail to the restless seminars at the university in the dusty town of Pataniganj, where quite surprisingly this year the oranges have developed blood-red segments, like their California counterparts, and their juice is more acid than anyone can remember.

Addressing the Dress

Richard Martin

Bruce Hainley, reviewing Kennedy Fraser's *Ornament and Silence: Essays on Women's Lives* in *The Nation* (February 3, 1997), commends Fraser's earlier writing on fashion, noting "in the seventies and early eighties, she continually noticed juxtapositions lost on almost everyone else. For all the buzz and hype about fashion and its satellite concerns (modeling, hair and makeup, beauty and fitness, etc.), there have been few critically reflecting on its ephemeral, nuanced meaning and erotics." Lauding the earlier work, Hainley concludes that Fraser who has admitted to becoming "a kind of daughter of *The New Yorker*" became in his essay's title "The Good Daughter," subject to protocol, politeness, and unbidden propriety, forsaking some candor, fierce criticism, and acerb innocence. If Fraser has succumbed, as Hainley argues, to the relentless seemliness of fashion's ingratiation and ambient comfort, she has inexorably lost critical distance

and discipline from the art that most overtly seeks to annul detachment.

Fashion criticism often falls victim to fashion's function in socializing and acculturation. If fashion bears the dual roles of self-expression and social registration, its criticism is inevitably a cultural criticism, addressing the abstract and applied terms of dress and appearance as a reflection of self-expression and self-confidence, but also implicating the terms of dress within the social contract. Fashion as a consumerist system exerts prodigious power; society, the entirety of our small and large social constructs, wields a like power over each client and potential purchaser. Fashion's penchant for the superficial and immediate is an undeniable characteristic, no matter how it is judged. Katherine Knorr reports in the *International Herald Tribune* (March 15–16, 1997), "Fashion, however, moves too quickly, too brightly, too commercially to do anything in depth or really dip into the artistic past . . ." In a polemical account denouncing the decadence of the nineties, Knorr asserts, "Fashion's genius is not in decadence, but in frivolity—the very best kind, the luxury of texture and color and draping and workmanship that makes fashion, at its best, come close to art." Such pronouncements are not uncommon, even if their premises are largely unexamined. We expect fashion to be superficial, possessing beauty only in the limited category of craft/dazzle; we assume that fashion's timely brevity is the soul of witlessness.

If criticism has never torn a building down inas-

much as architecture is an edifice of commerce and confidence, fashion criticism can seem a small and ineffectual force within the elaborate and lavish system of fashion creation, merchandising, and consumerism. *International Herald Tribune* writer Suzy Menkes has, more cogently and frankly than any other, addressed the recent absorption of fashion into media. Fashion's projection is, by nature, mediaphilic, ready to be soaked into other popular forms. In this role, the printed word of conventional criticism may assume even a diminished role. In an article "High Fashion's Future? Watch That Screen," (January 24, 1997), Menkes notes, "Like many of the spring/summer Paris shows, it [Thierry Mugler's runway show] was transmitted live on French television and will be screened around the globe. In that . . . the show was a metaphor for the current state of haute couture. The industry is undergoing metamorphosis, though no one quite knows what will emerge from the present confusion. And creating the right visual stimuli for the camera—rather than beauty, line, or workmanship—is now how high fashion must be judged."

Like art criticism, fashion criticism finds its Father Abraham in Charles Baudelaire and his keen observations of urban life oscillating between the ephemeral and eternal, splendidly superficial and repeatedly profound. Fashion's apparent favor to the superficial is yet arrestingly serious and consequential to Baudelaire in those matrix years for modern art and modern fashion, both emerging in a placenta of spectatorship,

bourgeois values, commerce, and nominal dissonance. Countless strollers in cosmopolitan streets, arcades, department stores, and malls have followed Baudelaire's footsteps. To be the boulevardier in the midst of things may not guarantee perspicacity, as Baudelaire's avowal of Constantin Guys might suggest, but it does assure that the observers of fashion and style evince involvement. Fashion's modern presence is not on a proscenium stage, affixed to a museum or gallery wall, or performed exclusively in designated sites of the spectacle, but is ubiquitous and pervasive.

Fashion's written record has often seemed as immediate as fashion itself. Once chiefly the domain of the "women's page" in newspapers, fashion's account was often mingled with its partnership with "society" news and notes. Even today, the "women's page" may have lost its afflicted name, but generally remains in the same position in newspapers, even separate from the new causes of modern domesticity and "lifestyle" that address both genders. A global financial newspaper devotes pages in its weekend edition to the arts in excruciatingly academic reviews of art exhibitions and concerts, but makes any reader turn the page to the heading "How to Spend It" to find fashion.

But does a journalistic account qualify as criticism? Amy Spindler, who joined the *New York Times* in 1993 as a junior fashion reporter eventually became fashion "critic," the first such designation in the newspaper's history. Spindler, who does not hesitate to offer judgment, provides little in terms of critical standard or

substantiation to her personal views. Spindler, writing under the *New York Times* rubric of "Review/Fashion," reports (March 15, 1997) in follow-up to a description of Helmut Lang's collection for fall 1997, "Mr. Lang is a very private man, but what he gave away of his personality at the show was that, at a time when he is the most copied designer of his generation, he has moved on and, with the new mood of sophistication, moved up, too. As if to signal the change, his once straggly long hair was groomed short and slicked back as he took his bow." Moreover, purported reticence may be hard to reconcile with the designer's omni-present advertising campaign using pages of Robert Mapplethorpe photographs; no Silas Marner is he who buys pages of provocative, deliberately aggressive advertising in the very periodicals where his work is most likely to be appraised. In such an instance, we seem to be promised systematic criticism and an ana-lytical function, but receive instead something more nonchalant and less exciting and, like Fraser's devel-opment as an author as characterized by Hainley, something more obedient.

Advertising's all too obvious and wholly uncritical seduction may often seem to overwhelm criticism's impertinent little voice. Indeed, fashion's commerce may even seem to suppress criticism. A fashion indus-try that clothes its art in appeals to the consumer in lavish advertising and display invests itself in the en-treaty and charisma as fully as in the discrete fashion product. The journalist-critic is likely to be viewed as

the mediator and facilitator, thus the greatest appeal of some fashion designers is to top editors and journalists. Runway fashion shows in Europe and the United States are more likely to seat major editors and writers in the front rows than even clients or merchants. The entreaty and the temptation to complicity do not stop with prime seating; some editors and writers have been known to accept gifts from designers that might compromise any writer's objectivity. The affluence and grandeur of designer lifestyles in the eighties and nineties offer risks in gifts of clothing, clothing loans, jewelry and accessories, and vacation privileges in food, drink, and lodging.

Conversely, designers have been known to exclude journalists from future shows for even mildly negative remarks, a banishment that could make it difficult for the journalist to do his or her job. McDowell rightly notes in *The Designer Scam* (1994), "To ban a journalist from a show is the equivalent of a weak school teacher sending a disruptive pupil to stand in the corridor—and just as childish. But it works . . . and designers feel that it concentrates the mind, encourages *les autres* and ensures that no one else will be so foolish as to criticise them again in the next few seasons."

Occasional mischievous or wayward writers or persuaders may be a smaller problem than the general environment of vitiated objectivity and of unquestioning enthusiasm in avoidance of critical judgment. Further, the lack of buttressing—or enforcing—by a

collateral academic discipline of historical or critical study like that of art history, theory, and critical studies may leave the journalist-critic without immediate recourse to a critical model, even as the blandishments of cooperation and congratulations arrive. The absence of the educational support and rigorous example that academic art history and criticism provide to their purview of mainstream contemporary art is acutely felt in fashion. Most especially in an art that touches the quotidian experience, historical recognitions and responsibilities are a worthy critical attribute. Journalist-critics such as Colin McDowell and Suzy Menkes are exceptional in knowing as much about art history and fashion history (and just plain history) as they do, but both have necessarily invented their armatures of understanding from their curious, literate, intellectual temperaments rather from recourse to the scholarly and museum communities that regularly augment the knowledge pertaining to contemporary art. Few fashion writers know anything about criticism or fashion history. The latter knowledge and information is, in fact, difficult to obtain. In the nineties, a shallow sophistry of "fashion theory," often compounded of gender and body-identity studies, has threatened to make the matter even worse in providing captious academic "buzzwords" of scant connection or contribution to fashion inquiry.

If the ingenious and industrious journalist, of whom McDowell and Menkes are models, constructs his or her own model of inquiry, how are these pene-

trating, trenchant thoughts to be taken in midst of a fashion discourse that is more accustomed to hyperbole and congratulation than to criticism? A long tradition of dicta from Diana Vreeland (who offered some haikus of cognizance amidst her stylish cryptograms), raptures from Polly Mellen, and bubbly babble from Carrie Donovan have encouraged the fashion conversation to be fatuous, subjective, and even unreasoned and bitchy. Fashion's institutional memory of language and comment is almost exclusively one of overstatement and embellishment akin to the gaudiest traits of a House of Worth dress. But Proust claimed that he would create his opus "quite simply like a dress," thus offering a more reasoned, no less impassioned, paradigm and metaphor.

Is fashion, in its industrial enterprise, expansive influence, and history of excessive rhetoric deserving of a more precise cultural rendering, even criticism? On one level, the answer is an unequivocal "yes," recognizing the enormous impact of fashion in our culture. Untamed by language and assessment, it threatens to be something powerful and uncontrollable. If we have long lacked the critical probity for certain craft arts—and fashion bears significant alignment with craft arts—we are nonetheless not culturally imperilled by our uncertainties regarding, let us say, ceramics. Critical abnegation in the formidable presence of fashion is, however, a dangerous cultural negligence placing every woman (and now every man) at significant risk of subjugation. There would be little

dispute that costume and fashion were once tyranni-
cal; our polity and our persons depend upon our not
ignoring fashion's force and charisma.

Yet would a serious criticism of fashion jeopardize
the energy and exuberance we associate with this art?
If we learn from other popular arts, including pho-
tography and movies, the presence of a critical re-
sponse does not inhibit but cultivates the art. In the
instance of $100+ million movies, criticism may not
be the most important index, but it remains a register
of values and perhaps most importantly it serves the
historical record and our responsibility to vet the cul-
ture of our time with our best ideas and thinking.
Glenn O'Brien and others have rightly argued that
fashion plays a major role in contemporary popular
culture because of its national fusion with the movies,
both being spectator-oriented, sexy, youth-driven,
magnificently superficial (in a literal sense), and posi-
tively ephemeral.

The recurrent "straw man" issue of fashion criti-
cism is the relationship between art and fashion. A
1996 exhibition "Art/Fashion" created by the tourism-
driven Biennale di Firenze was transplanted in spring
1997 to the Guggenheim Museum SoHo. Purporting
to syndicate or synergize art and fashion, the exhi-
bition chose instead to deny commercial fashion a
significant intelligence, preferring instead familiar im-
ages of the clothing metaphor created by so-called
"fine" artists. Yet not to confront and chafe our defi-
nitions and sensibilities for fashion and art is to as-

sume, more or less, the position posed by Knorr that fashion is so fleeting as to be inescapably banal, so superficial as to be incapable of completeness or depth. Of course, the unspeakable truth is that our definition of art as our century wanes is a troubled, malfunctioning denotation. For fashion has assumed, in a media age, the awesome properties of the spiritual and aesthetic, not merely in finery and finish, but in ideology and identity.

The diversionary issue of much style journalism in the nineties has been the pertinence and persistence of the haute couture, supposedly the supremely artistic form of fashion along with its consummate enactment on the runway. At the top of a prestige pyramid, but at the very bottom of the profit (and loss) food chain, the French couture has little to do with fashion as an expanded phenomenon of lifestyle. Loss leaders, exceptional garments are the style decoys intended to stimulate interest. Sensations of the most bustling, frenzied kinds are created around new young designers hired for venerable couture houses. Alexander McQueen, designer for Givenchy and beneficiary of a business mindset to fashion as explosive, uncultivated, outrageous ego, reports contemptuously of expectations of traditional couture clients. "The reason I am doing this is because I am twenty-seven, not fifty-seven" (*New Yorker*, March 17, 1997).

Beyond the inflated celebrities and egos of the LVMH enterprises, contemporary fashion should hardly be judged by its enticement alone, yet often it

is. In Italy, the revivals of the Prada and Gucci fashion houses have been stimulated by mediagenic fashion collections, much noticed by fashion reporters but little purchased or worn. Instead, many purchasers have been prompted by the vivid revival of the fashion names to acquire talismanic souvenirs in accessories, especially bags and totes. The process is similar to that in art: major acquisition is for the few who play a significant role in establishing taste, whereas most settle for the picture book or, in fashion, for the token. Arguably, Gianni Versace has undertaken a book publishing program in more direct emulation of the commodity system of art and its take-home souvenirs. After all, $75 for *Rock and Royalty* or *Men Without Ties* is an inexpensive keepsake compared to a scarf or a dress.

Even more than commerce as fashion's partner, fashion's proximity to sex makes criticism a treacherous enterprise. Fashion is a body-contingent, body-incorporating art. In its modern negotiation of gender, fashion exposes many matters of sensuality and sex that might confuse the decorum of criticism, or altogether defy decorum. Hal Rubenstein, then of the *New York Times*, saluted menswear designer John Bartlett in the program notes of the Council of Fashion Designers Award for 1993, as Bartlett was honored with the Perry Ellis Award for New Fashion Talent, beginning "Most people who meet John Bartlett want to eat him with a spoon." Admittedly, prodigies and young talents in all fields have sometimes been prized

for traits of youth beyond their specific aesthetic endowments, but fashion may seem to invite this personalizing, seductive attitude inasmuch as clothing is manifestly about gender and appeal. In our tendency to see character immanent in appearance (including, but not limited to dress), we are likely to see sexual traits chiefly through fashion, the paradox of the invisible or concealed being most visible and revealed. The nineties obsession with models ("supermodels") personifies this aggressive embodiment of sexuality filtered through fashion.

The long-standing fashion conundrum pertains to the assumption of a fashion designer's chief expression being a woman's body. Therefore, are Chanel and Vionnet the inevitable greats because they understand women in being women? Is the heterosexual male designer the ideal engaged, but not subjective, idealist? Is the gay male designer, distanced but capable of imparting idealism, the perfect designer? Few fashion journalists-critics for womenswear have been men; in a male (heterosexual) hegemony, the editorial and writing sides of fashion publications and fashion beats in newspapers have been a sanctuary for women, who have traditionally been denied other roles. A warhorse writer on fashion for a national newspaper admitted, near her retirement, that she had always wanted to be a political writer, but the opportunity never presented itself so she had had to be content with fashion.

In a sense, gender is fashion's first reckoning. Clothes have traditionally—since the fig leaves—and

in all cultures distinguished men from women and
vice versa. Fashion's account must begin with a hon-
est, open understanding of gender. Such issues, and
many more, are not wholly aesthetic, but they are, as
anyone would say of gender matters today, political.
In the same manner in which the arsenal of any critic's
thoughts is equipped with much more than descrip-
tive formalism, the fashion observer is wrapped in
clothing's gender constructs. Class, status, cost, modes
of manufacture/production are kindred political is-
sues of fashion, but none is as directly and urgently
present as the projection of gender, a matrix for fash-
ion's construction and for its consideration.

Gender seeks to chaperon sex in fashion, but sex is
always more visible and volatile. In recent fashion, as
in other arts, sex must be politically correct, but the
verdict on political correctness may be highly subjec-
tive. Menkes notes in *International Herald Tribune*
(March 15–16, 1997) of a John Galliano collection,
"Galliano's day clothes were shrunken school blazers,
striped knits and micro-mini pleated skirts, camped
up Lolita-style with stilettos and bobby socks. It was
part of a sex-pot schoolgirl theme which doesn't feel
good for women." Yet even for her discomfort and
gentle chiding, Menkes goes on to proclaim in the
following sentences, "Galliano's strength in this show
was costume. He brought to life Erté's art deco draw-
ings. He recreated Theda Bara for the 1990s with
his models as silent screen stars. And it was
wondrous—in its way." Menkes abjures the sluts and

jailbait innuendoes, but accepts the vamps, thus showgirls, but not schoolgirls. Menkes is notable and noble in even raising such reservations, but they are hard to argue in the limited space of a newspaper column where one expects celebration more than inculpation. Of course, how does one approach sex as subject without a distasteful feeling of censorship? To one woman, a Thierry Mugler dress may be a demeaning caricature of femininity; for another, it may be a fantasy of the unconstrained princess. If sexploitation is in the eye of the beholder, its presence is exacerbated as fashion increasingly includes menswear. Menkes wrote (*International Herald Tribune*, July 4, 1996) of Gucci menswear designed by Tom Ford, "Ford did not show much range, but he has a sense of irony. This enables him to send out not only luxurious suedes and sleek short coats, but nude-colored swimshorts, loud ties with giant G motifs and models with rumpled hair and yellow wraparound glasses. And there was the thong—strung from a Gucci logo to give a whole new meaning to the word G-string."

Fashion has generally been taken to be the practice of creating clothing for women. Men have been exempted from fashion, even though they wear clothing, though often of a more stable variety than the options and changes proffered by womenswear fashion. Yet as fashion creeps into menswear, fashion's gender issue is more equitable, involving men as subject and object for fashion. To date, little criticism has

addressed menswear, though the topic is intrinsically as efficacious and fascinating as women's fashion. In fact, open and evolving ideas of masculinity have become touchstones to menswear designers and would likewise serve their critics and commentators. Moreover, as Hainley demonstrates in his *Artforum* review (November 1996) of the Metropolitan Museum of Art's "Bare Witness" exhibition, the presence or even postulation of menswear perturbs and reforms issues of fashion for women. Hainley redirects an inquiry into women's bodies and identifies through fashion by his concluding interpolation, "When porn star Jeff Stryker dons leather chaps and nothing else for a porn-awards ceremony, his butt and cock bared for all to admire, it seems a moment fashion (or at least its historians) cannot ignore. Fashion thrives on that *between*—one skin meeting another." Therein, of course, both gender differentiation and sexual seeing, contact, and even consummation.

Even beyond the questions of the critical domain of fashion, there is the nagging question "What is fashion?", particularly with respect to the widespread phenomenon of fashion today. Journalists look primarily to the sensational stories of glittery runways and presentation in the fashion capitals of New York, London, Paris, and Milan. But there is also the ubiquity of fashion, a popular fashion as well as a high fashion. The American trinity—Donna Karan, Ralph Lauren, and Calvin Klein—cross in a multiplicity of products and fashion lines, to say nothing of massive

advertising, between a popular and high fashion. Still other fashion is more demonstrably pitched to the popular. Design, lacking the accustomed designer identity, is often neglected. Thus, Martha Duffy in *Newsweek* (September 16, 1996) offered an unusual address to Tommy Hilfiger: "Though he won last year's Menswear Designer of the Year Award, no one mistakes him for a designer in the usual sense. He hires others for that chore and concentrates on image making . . . As a young retailer Hilfiger dreamed of founding an empire like Ralph Lauren's, and he adapted Lauren's strategy of selling a dream instead of a line of clothes. If Lauren offers the charmed world of Scott Fitzgerald to the masses, Hilfiger is selling his own version of preppie, liberally laced with black-hipster fashion." Reporting in a news magazine and treating street to mainstream fashion as a social occurrence, Duffy considers fashion as a sociology and a marketing phenomenon more than as design probity. Indeed, it may be difficult to describe and analyze Hilfiger's winsome and successful design in any other terms, certainly those of a sequestered aesthetic.

If sociology suffices as a principal strategy of understanding for such popular fashion, how does one deal with the more equivocal fashions of social purpose and of concomitant design decision in other sportswear designers, such as Karan, Lauren, and Klein? Neither socioeconomic nor aesthetic-design exegesis alone satisfies in such instances. All too often, the designers that mingle popular dreams and design

desires are the ones most frequently ignored, perhaps in the uncertainty of analytical technique. Karan's definitions of the feminine (and correspondingly, in her menswear of the masculine) and of the body are undeniably a cultural configuration important in our time; Lauren's evocative interpretation of fashion's memories is as salient to our late-century aspirations as it is saleable; and Klein's plain luxuries in sportswear are rooted in the American ethos; yet all such notions are left unexamined while nonetheless in the room, the women come and go, talking of Donna, Ralph, Calvin, and Giorgio. The dearth of a more serious consideration represents a cultural reticence (to the body and fashion) as well as a lack of articulate commentary or commentators. All that inhibits our discussion, in fact, calls out for comment.

The need is even more urgent as fashion expands in influence. Fashion has always embraced the body. Contemporary fashion encompasses body and mind. Since the seventies, fashion has embraced the public space, placing its advertising, shopping, image-making, and media presence (especially television and ultimately the rock-fashion synergy and MTV) into the vast public sphere. Everywhere, fashion prevails. Fashion has conquered the public and private domains of contemporary life to be the all-encompassing *Gesamtkunstwerk* of modern life. Fashion is fulfilling a destiny to feed, clothe, and shelter modern affluence. No one specifically needs Ralph Lauren to determine paint colors and to cast housepaint in the aura of

fashion. No one needs Gianni Versace to return a comfortable opulence to favor with a luxurious combination of classicism and pop culture. An environment of barren minimalism does not need the sanction of Calvin Klein, but his clothes seem to complement the aesthetic. Fashion is no domestic intruder. Instead, it is our new comfort and desire, extending the consolation and satisfaction we have always taken from well-designed clothing into the home.

In a world of few certainties, fashion offers an effective model for self-selected authority. The individual has, in clothing, the right to choose among different styles. Yet once certain choices are made, there is a realm of reinforced satisfaction. The woman happy in Jil Sander and Yves Saint Laurent is not likely to go out and buy Versace. Fashion builds loyalty and it builds images. Fashion has come to be far more than clothing itself. As philosopher Gilles Lipovetsky has said, "Consumption as a whole now operates under the sign of fashion." Of course, the philosopher's statement is redundant; fashion is itself the highest form of consumerism and therefore leads all other consumer arts. Fashion's commanding position among the design arts suggests that others may make towels or teapots, but once the fashion designer enters the field, there is every likelihood that fashion will prevail, as historically it has in that ineffable area of fragrance which fashion appropriated in the 1910s and has never relinquished. Ironically, the only other

like disposition in media itself: for example, Disney or MTV may mean as much as Calvin Klein to American sensibility. To some, it must seem that fashion has opportunistically expanded to reach into nonapparel in order to buttress the fickle apparel business. But culture's evidence is contrary. The traffic has gone in the other direction. Fashion designers have been wheedled, cajoled, and even coerced into expanding their design in other fields that want the allure and authority which fashion alone possesses.

Increasingly in the twentieth century, and especially in recent years, we are witness to the preeminent power of fashion as our lifestyle art and belief system. Fashion has often been mistaken for its inherent property of being soft and its intrinsic desire to ingratiate. But, at the end of a century and of millennium, are we not realizing that harsh realities demand not more cruelty and unpleasantness but the comforts and the pleasures that fashion has always provided?

One arena in which one might expect to see fashion addressed critically is art criticism, that is, the criticism of the fine arts, but a lingering hierarchy and privilege of the fine arts have all but excluded any consideration of fashion. A recent study by Sung Bok Kim (*Fashion as a Domain of Aesthetic Inquiry* . . . , New York University Ph.D. dissertation, 1997) reviewed the literature on fashion in the chief American art magazines in the eighties and nineties. Kim found little trenchant or systematic thinking in most of this writing. In fact, the occasion for many of the essays

was to review museum exhibitions of costume, not to afford the periodic assessment of themes, categories, or an artist's work as one might find of the same journals in consideration of contemporary art.

Veteran and honest fashion writer Colin McDowell has written in *The Designer Scam* of fashion's critical deficiency. "In a world in which there is no blame, praise becomes meaningless. This is a dangerous situation for business or artistic endeavours: it strips away internal rigour and lays the way open for unchecked indulgence." If fashion is the constructed convergence of our bodies and our perceptions, how can we allow this intersection of our most crucial, vulnerable, concerns to go unexamined? When we acknowledge how important fashion is, how can we be dumb and toadying in the presence of its makers, purveyors, and persuaders? We desperately need fashion criticism. When we neglect the ordinary, the option for the extraordinary vanishes. If we ignore the quotidian and commercial, we are doomed to speak only of the venerable and awesome. If we cannot consolidate compound languages to address multiple styles, effects, and interests, we are left with mere description in any critical discipline.

One remembers that the first and only fashion critic, save perhaps Baudelaire, was a child who most shamed not an emperor who had failed to dress but all who had failed to address.

The Film Critic of
Tomorrow, Today

J. Hoberman

We've been here before. As the aesthetician (and erstwhile movie reviewer) Rudolf Arnheim predicted in 1935,

> One of the tasks of the film critic of tomorrow—
> perhaps he will even be called a 'television critic'—
> will be to rid the world of the comic figure the
> average film critic and film theorist of today rep-
> resents: he lives from the glory of his memories
> like the seventy-year-old ex-court actresses, rum-
> mages about as they do in yellowing photographs,
> speaks of names that are long gone. He discusses
> films no one has been able to see for ten years or
> more (and about which they can therefore say ev-
> erything and nothing) with people of his own ilk;
> he argues about montage like medieval scholars
> discussed the existence of God, believing all these
> things could still exist today. In the evening, he sits

with rapt attention in the cinema, a critical art lover, as though we still lived in the days of Griffith, Stroheim, Murnau, and Eisenstein. *He thinks he is seeing bad films instead of understanding that what he sees is no longer film at all.* [emphasis added]

The crisis in film criticism has been variously linked to the consolidation of entertainment conglomerates, the proliferation of home video, the dumbing down of the movie audience, the toxic fumes of film theory, the death of cinephilia, the retirement of Pauline Kael. True enough, but is the crisis not even more fundamentally related to the disappearance of movies?

Not literally, of course. Indeed, the Movies occupy more cultural space than ever before. *Entertainment Tonight* commands as much broadcast time as the evening news. Entire cable stations are devoted to the promotion of new movies and stars—who exert more power and make more money than at any time in human history. Grosses too are generally up and Oscar night, the annual festival of self-congratulation, has become a "feminine" counterweight to the "masculine" Super Bowl in the celebration of national identity. It's almost a patriotic duty to be entertained in America—even a form of unpaid labor. For busy people, there is Time Warner's *Entertainment Weekly* to provide a convenient substitute for actual consumption. Freed from the obligation to see-hear-read all this stuff, you can flip through the magazine, glom

the letter grades, and be knowledgeable. You can have opinions.

(And just what is it that you, reader, want to know about a movie that you have never—and may never—see? Is it an account of the narrative action—stopping too short to protect of the various twists and surprises? Is it an amusing description of the physical appearance of the—hot? cold?—stars? A sober evaluation of the competence of the cinematic technique? An assessment of the manifest directorial personality? Is it speculation on the movie's place in—movie?—history, the degree to which it embodies the way we live now? Did you really care if I liked it—and why? Is the question whether to buy a ticket to see the movie now—or wait for video?)

What else is there to say? Familiarity may breed contempt, but commercial cinema trades on prior acquaintance. (In no medium is the stigma of the "difficult"—which ranges from the absense of stars to the presence of subtitles—more damning.) Stars are a form of living trademark, scripts a kind of organized cliche. Genres rule. Movies are made in cycles and recycled as remakes. Anything sold once can be sold again . . . and again. Moreover, the movies are the nexus for an endless series of cross-references and synergistic couplings. Just as movies are now routinely based on old TV series, so plays are adapted from old movies. So-called novelizations used to be written after a movie was released; now they are published before the film is made.

The more old Hollywood movies are sentimental-
ized as art, the more crass our appreciation of the
current crop. A flop is, by definition, an aesthetic
failure; quality is synonymous with economic success
(or at least notoriety). Although critics continue to
grouse over the decline in narrative values, the story-
line that everyone in America has learned to follow is
the fever chart of box-office grosses. Every major pro-
duction brings its own ephemeral *Entertainment To-
night* metadrama. Each summer, audiences are invited
to be a part of History by queuing up to see *Indepen-
dence Day* or *The Lost World*—the resonance of
these titles!—on their first megamillion-dollar week-
ends.

* * *

A movie is almost by definition a record of that
which once was—and how we long for that which no
longer exists! Fifty-eight years after *Mr. Smith Goes to
Washington*, *Variety* reported that the most most
trusted man in America was still Jimmy Stewart.

In the moment of national self-analysis that fol-
lowed Stewart's death most marvelled over his old
fashioned virtues, his lack of pretention, the miracle
of his actorly "ordinariness," the positive values of his
persona. The fact is, however, that stars are our su-
preme public servants. The mild gossip that doings
and vehicles inspire promotes the socially cohesive
illusion of an intimate America where everyone knows
(and even cares) about each other. The stars—and the
entertainment media that showcase them—create

what the theorist of nationalism Benedict Anderson has called an Imaginary Community. And not just ours—by 1995, as American movies filled the vacuum left by the declining indigenous film industries of Europe, Latin America, and Asia, foreign rentals had surpassed those of the domestic box office.

In the totalitarian Soviet Union, entertainment was an obvious aspect of the state ideological apparatus— merging politics with show business. Of course, we can't say that of America (at least not on television). Nevertheless, this Imaginary Community—predicated on the existence of shared tastes, feelings, desires—is an economic necessity. For if the prerequisite of mass production is mass consumption, that mass consumption is itself predicated on the production of mass desire—for movies, among other things. And, because virtually all reviewers are compelled (as journalists) to write about films before most people have a chance to see them—thumbs up or down like parody Roman emperors—they are only one more part of a vast machine devoted to inculcating the mass urge-to-see.

Although movie reviews are historically the favor with which newspapers acknowledge the placement of movie advertisements, the ads now in effect commission their own six-word reviews (while serving the secondary function of providing free publicity for the reviewers and, of course, the periodicals or broadcast outlets that employ them). To be a movie reviewer is to strike a Faustian bargain with the industry. You can

have your name (and your words) emblazoned on a newspaper ad or poster as large as that of Tom Cruise. Does anyone doubt that many reviewers write to be quoted or paraphrased? Some phantom reviewers exist only as pull quotes. (The industry term for them is "blurb whores.") In 1989, Rex Reed complained to *Variety* that studio publicists had asked him if he would polish a quote; eight years later, *Variety* was reporting that at least one studio had taken to faxing readymade quotes to freelancers, inviting them to attach their name to the one found most agreeable.

United in their need to promote the latest blockbuster, studio press agents and movie journalists enjoy a symbiotic relationship. (*Premiere*, a periodical at which I worked for a half-dozen years, transformed on-set reportage into a—marginally—more literary form of the studio press book.) Studios typically mark the opening of a major investment by organizing an industry junket, flying reviewers from all over the country to Los Angeles or New York to preview the movie, enjoy a hotel banquet, and then attend a succession of five-minute group interviews with the stars. Categorizing journalists in terms of their use-value, publicists trade early screenings, film clips, and access to the talent for sound-bites and advance superlatives.

The magazine journalist is thus a part of the movie's anticipatory build-up as well the magazine's own competitive struggle to secure the star-image for its covers. Celebrity is the coin of the realm—the ultimate in surplus value which, through the magic of

endorsement, transforms, as Marx wrote in *Capital*, "every product of labor into a social hieroglyph." Publicists routinely vet writers, stipulate format and ground rules, and barter for cover placement (and, when they can, other aspects of editorial content). While publicists understand the press as a potential rival in the creation of a star's persona, the underlying assumption is that journalists, like reviewers, are too stupid or star-struck to realize how much more money they could make writing screenplays or even press releases.

Once upon a time, media commentator James Wolcott wrote in the April 1997 *Vanity Fair*, film critics "had the oral swagger of gunslingers. Quick on the draw and easy to rile, they had the power to kill individual films and kneecap entire careers." Then the frontier closed. Faced with the silence of his idol Pauline Kael, Wolcott laments that "movie criticism has become a cultural malady, a group case of chronic depression and low self esteem." Reinforcing his point is the fact that the vehicle for his screed is a journal devoting an extraordinary amount of space of movie and movie stars without apparently feeling the need for regular film criticism.

* * *

In addition to bankrolling remakes, Hollywood studios are primarily interested in recycling movies as theme-park rides, interactive videogames, CD-ROMs, and computer screensavers. This is one meaning of Andre Bazin's "Myth of Total Cinema."

Anticipating by some decades his compatriots Guy Debord and Jean Baudrillard, Bazin forsaw the historical logic by which the movies and their more perfect successors would inexorably seek to supplant the world: Virtual Reality.

The key development, but only thus far, in the Myth of Total Cinema was development of "talking" pictures in late 1927—the magical simultaneity of sound and image is what the Austrian avant-garde filmmaker Peter Kubelka called the Sync Event. It was, in fact, this particular technological advance that prompted Rudolf Arnheim to declare of the film critic that "he thinks he is seeing bad films instead of understanding that what he sees is no longer film at all."

Time Warner and Walt Disney, the world's two largest media conglomerates, were both founded upon the miracle of synchronous sound. Talking pictures brought forth first *The Jazz Singer* and then, the far more durable blackface entertainer, Mickey Mouse. The Mouse is prophetic of Total Cinema's next stage, namely the overthrow of camera authority by computer digitalized imagery: More and more, the future begins to look like Paula Abdul's four-minute "remake" of *Rebel Without a Cause* or the computer-animated Diet Coke ad where her fellow flack Elton John jams with Louis Armstrong for the amusement of Humphrey Bogart. The living party with the dead under the sign of the trademark, the gods dwell among us from here to eternity.

The very name Time Warner suggests the fusion of

news and entertainment—indeed Warner's summer 1996 blockbuster *Twister* was featured on the *Time*'s cover as the hook for a news report on tornados. Rival retail outlet Walt Disney is called for the corporate artist supreme—the single most important figure in mass culture, the first to saturate America with cultural trademarks, to use television to create a system of self-perpetuating hype, a creator so universal his quirks must be stamped on our DNA and his Magic Kingdom now incorporates a substantial chunk of midtown Manhattan. (Might we not balance the budget by establishing the American flag as a registered trademark, licensed exclusively to Walt Disney?)

Following Disney, the successful Hollywood movie is an increasingly uninteresting bridge between the multimedia barrage of prerelease promotion and a potential package of spin-offs, career moves, and tie-ins. (Such ancillary income exceeded even the box-office grosses for such megablockbusters as *Batman* and *Jurassic Park*.) As reported in *Time*, Time Warner chairman Gerald Levin heralded the media conglomerate's Christmas 1996 release—an epic synthesis of an animated Looney Tune and a Michael Jordan sneaker commercial—with unusual candor: "*Space Jam* isn't a movie. It's a marketing event." Disney's summer 1997 animated feature, *Hercules*, went even further (while preempting any criticism) by satirizing itself as a marketing event.

Awaiting the fulfillment of Total Cinema, Americans already live in the world of Total Docu-Drama.

(Think of it as the live-action and cartoon mix of *Who Shot Roger Rabbit*?) The television induced symbiosis of entertainment, history, and politics is so complete that no one complains when *Star Trek* memorabilia is enshrined, alongside actual moon rocks and Lindbergh's authentic *Spirit of St. Louis*, in America's equivalent of the Sistine Chapel—the National Air and Space Museum in Washington, D.C. This technology for manufacturing evidence is what we have to remember us by—shared projections of an imaginary past.

As predicted by George Lucas's *American Graffiti* and demonstrated by his *Star Wars*, as illuminated by the careers of Steven Spielberg and Ronald Reagan, Hollywood is the main repository of cultural memory—and authority. In her introduction to a recent collection of scholarly essays on *Schindler's List*, Israeli professor Yosefa Loshitzky notes that making the film had effectively made Spielberg more than an artist: his "testimony in the summer of 1994 before a congressional committee examining the issue of 'hate crimes' itself testifies to the fact that the most successful commercial filmmaker in Hollywood's history has suddenly achieved 'expert' status on a controversial and complex social phenomenon—purely by virtue of having directed a film whose subject is the rescue of a handful of Jews from the Nazis."

Any news story in the cinema-saturated world can be played like an old-fashioned pinball machine—ricocheted from one mirrored surface to another.

Within weeks of the now barely remembered tale of Tonya Harding's alleged assault on her Olympic skating rival Nancy Kerrigan, the *New York Times* reported that no less than ten film production companies "as well as networks and studios" were seeking the rights to the story. Since then magazines have been aggressively shopping the movie rights to material they publish, while the Disney studio has taken the lead in directly commissioning journalists to investigate stories—eliminating the magazine middleman. Similarly, the Heaven's Gate cult (named for a film) is but the bridge from *Star Wars* and *Close Encounters of the Third Kind*, from which it drew its theology, to a made-for-TV movie.

"Fiction seeps quietly and continuously into reality," writes Benedict Anderson, "creating that remarkable confidence of community in anonymity which is the hallmark of modern nations." In the context of a world inexorably transformed into a representation of itself, the big-budget film biography or historical reenactment—once the ultimate middlebrow made-for-TV mode—has come to seem the quintessential Hollywood genre. Self-proclaimed countermyths like *Patty Hearst, Born on the Fourth of July, The Doors, JFK, Ruby, Malcolm X, Quiz Show, Hoffa, Schindler's List, Panther, Apollo 13, Nixon, The People vs. Larry Flynt*, and *Evita*—as well as their fictional, satirical, or avant-garde counterparts (*Forrest Gump, Ed Wood, I Shot Andy Warhol* are to the post Cold War Bush–Clinton transition what the Spielberg-Lucas megafan-

tasy had been to the Age of Reagan or what the epic of antiquity to the early fifties—spectacular displays of pure movie might, would-be interventions, contributions to (or, perhaps, substitutions for) a national discourse.

In the absence of what had been considered film, Arnheim reminded the critic of 1935 to recall that "second great task"—often neglected by virtue of the demands required by "aesthetic criticism"—namely, "the consideration of film as an economic product, and as an expression of political and moral viewpoints." How can we do anything else? As Arnheim's colleague and contemporary Siegfried Kraucauer put it, "the good film critic is only conceivable as a critic of society." (Now, of course, the reverse is also true.)

* * *

As explicated by Terence Davies's 1992 masterpiece, *The Long Day Closes*, movies are both the most subjective of individual experiences and the most public of public arts. Davies's ten-year-old alter ego is charged by a love for the ineffable—a fascination with that world on the screen we never see.

Is that love gone? It was just past the hundredth anniversary of the Lumières brothers' first public exhibition of their cinematograph when Susan Sontag lamented the death of cinephilia with an article published in the *New York Times Magazine*: "Cinema's one hundred years seem to have the shape of a life cycle: an inevitable birth, the steady accumulation of glories

and the onset in the last decade of an ignominious, irreversible decline."

Readers of the *Times* were quick to point out that Sontag's view of cinema was a highly selective one. She maintained, for example, that only France produced "a large number of superb films" for the first twenty-five years of the sound era (and presumably thereafter). She made no mention of current Chinese movies or even American independents (or Chantal Akerman or Atom Egoyan or Raul Ruiz or Lars von Trier or Stan Brakhage or Beat Takeshi or Abbas Kiarostami . . .). She capped her career-long disinterest in American movies by mourning the blighted careers of Francis Coppola and Paul Schrader.

As ahistorical as it was, Sontag's piece nevertheless partook of a now-familiar melancholy. The approaching millennium, the AIDS plague, the collapse of "existing socialism," and the end of the Cold War have inspired many such obituaries to mark the real or perceived disappearance of many wondrous things— modernism, historical consciousness, oppositional culture, the literary canon, American industry, the Democratic Party, New York City, baseball, the Broadway theater, downtown nightlife, labor unions, print journalism—all to be replaced by the bogus virtual reality of an impoverished cybertopia. In truth, the movies have merged with the spectacle of daily life.

The cinephilia of the sixties is over—it required not only the films of the sixties but also the social moment of the sixties. If the sixties and seventies

brought a film culture of unprecedented plurality, the last twenty years have been characterized by increasing self-absorption, a profound ignorance of world cinema, and a corresponding disinterest—among American critics, as much as American audiences—in other people's movies. More disturbing, perhaps, than diminished film enthusiasm is the failure of the sixties film culture, which Sontag herself helped create, to establish itself as a lasting intellectual presence. (After Reagan, one might expect that movieology would be the central pursuit of the age. But there is still something suspect in taking the movies too seriously—except, of course, as a business.)

Sontag's two-page spread included a cover image of *Cahiers du cinema* but failed to note the French journal's ongoing debate on the nature of movie-love. "Is it necessary to cure cinephilia?" was the question posed by *Cahiers*'s January 1997 issue, which in sampling the writings of Ricciotto Canudo (1879–1923) resurrected a cinephilia no less intense than that of the sixties. "What is striking, characteristic, and significant, even more than the [cinematic] spectacle itself," Canudo wrote in 1911, "is the uniform will of the spectators, who belong to all social classes, from the lowest and least educated to the most intellectual." Canudo saw in movies a "desire for a new *festival*, for a new joyous *unanimity*, realized at a show, in a place where together, all men can forget, in greater or lesser measure, their isolated individuality."

That festival is "Hollywood"—the quaint name

for an international mass culture, based in the United States but drawing capital, talent, and audiences from all over the world. A celebration of American military and cultural hegemony, *Independence Day* was the pure cultural expression of the formula PR + F/X = USA #1. As *Independence Day* united America before one movie, so the movie showed America organizing the world to establish July 4th as a global celebration of independence—from what? Surely not Rupert Murdoch, the immigrant lad who bankrolled the flick.

Is movie criticism then inevitably a form of publicity? Or, put another way, is it even possible to position oneself outside the media system? (For most of the nineties, the national film industries that have inspired the greatest degree of cinephilic enthusiasm have been those of the designated outsiders China and Iran.) Who wants to be the festival's spoilsport?

There is a sense in which print criticism is obsolete anyway. After all, that which television ignores can barely be said to exist. While making his bitterly confessional *Ginger and Fred* (1985), Federico Fellini—for decades the popular notion of the individual film artiste—spoke about "the enchanted palace of TV." Taking its title from a pair of star-imitators, *Ginger and Fred* is set in a hermetic, controlled environment—the Cinecittà studio transformed into something like a mall—where entertainment feeds on entertainment. This is Fellini's complaint: In an image-glutted world aspiring to the complete com-

mercial saturation of cable stations like MTV or the
E! Channel, the movies have disappeared. Even the
great Fellini has been out-Fellinied by TV.

Sneering at the ersatz, *Ginger and Fred* is filled with
celebrity imitators—but, as Andy Warhol under-
stood, celebrity is infinitely recuperable. Tim Burton's
1994 *Ed Wood* results from one of the most bankable
filmmakers who ever lived expending the credit of his
success in sincere, black-and-white tribute to the ob-
scure, tawdry vision of the alcoholic, heterosexual
transvestite and sometimes pornographer known af-
fectionately as "the world's worst director." There is
no such thing as negative publicity and to be the
World's Worst Filmmaker is to personify a particular
high concept.

Celebrity is absolute and *Ed Wood*, of course, is
absolutely flawless—as fastidiously crafted as any pre-
vious Burton production. Burton's painstaking repli-
cation of Wood's haphazard compositions suggests a
vanished Hollywood landmark, the Buena Park Palace
of Living Art where the Mona Lisa or Whistler's
Mother are reproduced as garish wax dioramas and
the Venus De Milo is improved upon, not only for
being colorized, but through the restoration of her
lost limbs. *Ed Wood* is the Palace of Living Art in
reverse. Art is not reproduced as kitsch; living kitsch
is embalmed as art. Deliberately or not, Ed Wood
served to deconstruct all manner of Hollywood pre-
tense. *Ed Wood* builds it all back up, better than

new—the movie's greatest irony is the liquidation of irony itself.

> We know very well that occasionally—and this
> will also be true in the future—in the hand of an
> avant-gardist, a narrow-gauge film amateur, or a
> documentary hunter, a true film is still made, but
> the work of a critic cannot be concerned with such
> exceptional cases. It must instead deal with every-
> day production, which can only be subjected to
> aesthetic criticism when a production falls into the
> realm of aesthetics in principle; that is, when it has
> the possibility of creating works of art. Formerly,
> good films differed from mediocre ones only in-
> sofar as their quality was concerned; today they are
> the outsiders, remnants, things of a basically dif-
> ferent nature from that which normally passes
> through the cinemas.
> —Rudolf Arnheim, "The Film Critic of
> Tomorrow"

Yes, but . . . how does one resist? Is it by defending underground movies on the internet? Extolling enter-tainment that refuses to entertain? "*Mars Attacks!* is *meant* to be a kind of anti-entertainment," the critic for the celebrity-driven *New Yorker* wrote incredu-lously of Burton's megamillion dollar dada jape.

Similarly, the 1996 Jim Carrey vehicle, *The Cable Guy*—a jarringly violent, slapstick meditation on role-playing, performance, and the E! Channel

totality—was attacked precisely for its own, unexpected attack on the system that produced it. "The shocking sight of a volatile comic talent in free fall," per the *New York Times* review, explicitly playing a stellar public servant (and architect of the E!-maginary Community), Carrey's $20 million "cable guy" *was* mass culture, precipitating the latent hostility felt even by the festival's most dogged celebrants.

The Mystery Science Theater 3000, for several seasons a regular feature on cable's Comedy Channel, inscribed an animated pair of wise-cracking humanoid spectators over their presentation of the worst, most inept drive-in features of the fifties—including, of course, those by Ed Wood. The aggression that *MST3K* (as its fans abbreviate it) directed at those hapless old movies that fell into its deconstruction machine is the inverse of the idiotic positive "reviews" that blurb whores can be relied upon to lavish on the most disposable current release. *MST3K* is a rearguard action too be sure, but we might learn from it.

Why settle for a mere laudatory blurb when the entire enterprise is available? Total cinema is our second nature and, as Griffith, Eisenstein, and the Surrealists long ago demonstrated, cinematic meaning is a factor of context and juxtaposition—not to mention purposeful derangement. (In a social sense, we might call this reeducation.) Sooner or later—or rather, sooner and sooner—the most elaborate $100 million blockbuster will fall into your hands as a $19.95 video cassette.

Just as the most radical recent examples of film criticism have, by and large, been "found footage" compilations like Craig Baldwin's *Tribulation 99*, Mark Rappaport's *Rock Hudson's Home Movies*, and Chantal Akerman's *Chantal Akerman by Chantal Akerman*, so the most important film critic of the past thirty-five years has, of course, been a filmmaker. "The greatest history is the history of the cinema," Jean-Luc Godard told Serge Daney.

That history will force those critics refusing the role of underpaid cheerleaders to themselves become historians—not to mention archivists, bricoleurs, spoilsports, pundits, entrepreneurs, anticonglomerate guerrilla fighters and, in general, masters of what is known in the Enchanted Palace as "counterprogramming."

Why Bully Literature?

Wayne Koestenbaum

I don't usually consider myself a curmudgeon, but that is the posture from which I will speak for this essay's duration.

I wish to divide my subject in two: journalism (book reviews) and professional criticism (academic books and essays).

The media pay for reviews, whether the journals and magazines are underground or parts of conglomerates. Universities pay for academic books, either because university presses publish them or because schools employ the critics.

The two modes overlap. Nonacademics write monographs. Academics write reviews. A book review might concern as an academic project; reviews appear in scholarly journals, which are often subsidized by universities. The styles of journalists and academics are not always different. But the sources of funding are separate, and therefore so are the stakes.

* * *

Book-reviewing is a time-honored trade. It used to pay more than it now does. I presume that in the days of George Gissing's *New Grub Street* or the early days of American literary publications, one could eke a living out of it. Today, magazines and newspapers employ full-time reviewers, but other reviews are largely written by freelancers, whose objectives are various: to earn money; to earn legitimacy (the role of arbiter); to dominate the writer under review; to declare affinity, sometimes in hope of deferred, concrete reward but more often from honest collegiality; to promote a school, style, or aesthetic; to push the tide of taste in a new direction. The desire to enter a dialogue, through book-reviewing, expresses faith that the evaluation of current books constitutes a public forum, a theater for the open exchange of ideas.

Anyone who has written a review knows what a trying exercise it can be.

Whatever the reviewer's motives, they are overshadowed by a review's function—news, advertisement. A review advertises the book's existence, to however small a community. More books are published than receive reviews; entire categories of books (I am thinking, now, of poetry) live far from hope of review, without which a book may be said only to have a subterranean, virtual existence (a quickly smothered cry in the dark). To call a review an ad, a death notice, a statement of bankruptcy or foreclosure, is not to deny its emotional and intellectual fruits, or to claim

that we are merely puppets of commerce, but to boil the review down to its essence, which is licensing and certification, as if for citizenship, birth, or death.

The pleasures of reading (and writing) a review are interpersonal, like love and war. A review restores combative erotics to the dry, solitary practice of writing. Let us call the two parties "reviewer" and "writer," though both, of course, are writers. The reviewer stages the scene, decides whether it will be a sadomasochistic ritual, or light petting, or a catatonic refusal even to acknowledge the existence of the writer, as if the book under discussion were a knob of kohlrabi, brought to life by no human hand. The writer, in theory, dominates; the reviewer is necessarily the parasite. The reviewer's unhappy dependence on the other often leads to trouble.

A book review is a scene of judgment, with one body in the judge's chair, the other in the defendant's. As long as this dynamic is not acknowledged, the book review, as a genre, can only be a dismal thing, one of the least evolved, least conscious, and most embarrassed of contemporary forms of expression. Embarrassed, because it can only have a defensive relation to its affects—either overcompensating by *refusing* to judge, or wholeheartedly and unironically participating in the hostilities. Too often a book review is a scene of scapegoating, and any pleasure we take in reading it stems from the atavistic joys of being a voyeur to someone else's suffering.

I'm not suggesting we replace objective evaluation

with unthinking hugs, gold stars pasted on every writer's forehead, cupcakes for everybody in the room ("Everyone's the birthday boy and girl today!"). But I do propose that we examine why we consider evaluation to be the primary function of criticism, and why abuse cannot take place in privacy, *prior* to the writing of the piece, so that the books deemed unworthy are not reviewed, freeing the page for works that deserve notice. I have often marveled at the prodigal waste of space in widely circulated organs, whereby books that merely occasion a reviewer's display of spleen are given prominence, as if there were not hundreds of shipwrecked books that never receive adequate attention. I suggest that the exercise of sanctioned aggression known as book-reviewing be retired and replaced by passionate acts of advocacy. Writing a review takes enormous work. I cannot imagine summoning the energy if I didn't feel that I needed to save a book from certain death, to wedge it into a crowded marketplace, to support a kind of writing that I esteem. The only other reasons anyone accepts a reviewing assignment are cultural capital and money—and resentment, which, if not funneled into creation (rather than demolition), is one of the ugliest spectacles in the civilized world.

Furthermore, I question the notion that some literature is new and therefore worth reviewing, and that other literature is past the statute of limitations. As any devotee of revival houses understands, the old artifact, brought to light, has as much to say about the

present time as do any number of recent works. I learn more about contemporary literature from obituaries than from the majority of reviews. Recently, for example, I discovered in the newspaper that French novelist Robert Pinget died. That stark announcement had for me the power that any number of reviews lack. Now that Pinget is dead, unless a work is reissued, or a posthumous novel emerges, there will be virtually no place for him in the book-reviewing industry. The next time I read a gratuitously nasty review I will wonder why the same amount of space wasn't given to an advertisement of Pinget's novels, which haven't yet been assimilated into North American literary culture. Because book reviewing has a servile relation to the publishing industry (only the release of a book can occasion a review, except in those journals which regularly devote space to reconsidering lost works), a review can only direct its gaze on a book that is fresh on the market. Nothing is more shopworn than a book whose only hold on our attention is recentness; I suspect that there are more exciting books lying unread and unpublished in archives than appear in print and therefore in review.

* * *

Academic literary criticism consists of evaluation, contextualization, theory, advocacy, and explication. Most specimens are published by university presses. Most are written by present, future ("aspirational"), or former academics. There is a long tradition of critics without college affiliation, but given the absorption of

writers into the academy, whether as adjuncts or full-timers, independent criticism is rather lost to us. (There remain many writers who move in and out of academic asylum, and whose labors as translators, critics, poets, novelists, essayists, scriptwriters, and pornographers do not fall into the neat divisions I am espousing.)

I see two reasons why academics write literary criticism; the two are so tightly interwoven that it is almost impossible for me to be coherent about this subject. The first reason is intellectual curiosity, the desire to know and to explain: criticism is a response to passionate knowledge, and it is a chance to feel the sheer pleasure of exercising and displaying a craft; proposing directions that culture and aesthetics might head; correcting misperceptions; messing with the past; preserving prior artifacts (letters, fictions, poems, documents, testimonies), whether in the form of scholarly editions or texts for general readers. At the core of good academic work lie desire, conviction, transference, and imagination; no one puts together a scholarly edition or composes a critical book without a burning need to travel into an idea by communicating it, and to act on identifications as unspeakable and rich as those that lead a novelist to create a character. Sentences are difficult and treacherous to write, whether they be in a novel, a poem, a journalistic book review meant for many readers, or a work of abstruse theory meant for few. The demanding agent is the sentence itself, not the size of the audience.

The second reason an academic writes a work of literary criticism is professional legitimation: to acquire or retain a job, and to ensure advancement. I've almost never heard anyone say this, though it seems obvious, and not shameful: *academics write literary criticism for money*. They also write for cultural capital, or prestige—within the university, within intellectual communities, within disciplines—but to remain valuable, cultural capital must inevitably turn into money, or into a form of professional status so close to money, and so suggestive of possible remunerations, that we might as well bite the bullet and call it money. Other noble professions, including medicine and law, are also practiced for money; the desire for income and status isn't neatly divisible from the desire to do good, to heal, to assist, and to defend. Academic criticism pretends to exist in a world of value apart from commerce, when in fact it is as driven by commerce (in the mediated form of legitimation) as journalism is. Literary criticism responds to the academic market, just as art criticism responds to the art market. In the world of visual art, it is impossible to forget the centrality of money, not only because the artifacts have prices, but because visual art, in its customary status as an enticement to (or an assault on) the eye, has more affinity with the culture of shopping than do morose, insentient texts. It takes work to make text pricey, to imagine it as laden with value. And so full of mystique, therefore, is literary criticism, so remote from the sensual market of commodities, that no aca-

demic would be caught dead saying he or she practices it for the money. It may be a point of pride to assert that criticism—often referred to as "my own work," to distinguish it from the dreary business of the classroom, which one is free to admit is labor contracted for financial reward—makes no money. The work's relative noncirculation testifies to its efficacy as sheer value, like an heirloom diamond ring only shown to family but never taken to the jeweler for an estimate.

Pretending not to have a price is as toxic a behavior as any other exercise of ignorance: it protects one from the fresh, if unwelcome, air of genuine thought, which may not at all, in some of its finest forms, resemble thinking. Literary criticism, at its best a curatorial business (scholars provide us with texts to read, as musicologists provide performers with scores to play), is a half-paralyzed beast moving blindly toward the monetary light and insisting that it be called darkness. The beast can't move, but it can talk. Verbosity and perpetual production—the factories are humming—fill a silence that might better have taken the form of introspective awe. The question that I almost never hear an academic, including myself, ask, is "Why bother?"

Intellectual work isn't merely bother; anyway, tedium plays a considerable role in every art. But I cannot begin to consider the crisis of literary criticism—cannot begin to imagine what kind of work I'd wish to see proliferate—as long as the practice remains obfuscated by its pretended remoteness

from money. How can one even see the face of literary criticism, when it is so obscured by veils? Frankly, I don't know what literary criticism is, except a method for chasing value to its lair; an institutionalized style of hunting down profit, under the guise of there being no profit at stake; a highly aesthetic game that is as much a trade as is the design and marketing of garments; an industry that purports to capture the truth of its prey (but is entirely contained by what it hunts); a parasitic practice of commentary that is to literature what pornography is to sexuality. Porn, like criticism, can be a beautiful ritual. Because porn actors aren't searching for abstract forms of capital, their performances approach austerity; there is no slippage between what they seem to be doing and what they are really doing. In academic criticism, the slippage is huge. Critics seem to be making purely intellectual claims, but they are also seeking a legitimacy that entails economic security and the power, eventually, to grant others a similar stature, or to withhold it. Such motives, which abound in professional lives of any stripe, are, for academic literary critics, shameful secrets.

I hardly propose the eradication of the literary critical industry, in which I have at times eagerly participated. Indeed, I oppose any propositions to shut down milieux of text or voice. I am happy to see literary critics, myself included, continue the droning production of embroidered cloud cover.

It's déclassé to mention price. "How much did that

stereo cost?" I asked a friend who had just purchased an elaborate system, and she responded, "None of your business." In the academy I've often felt like the rude fool who asks, "How much does literary criticism cost?" The answer is always, "None of your business." The reluctance of academics to question the stylistic protocols of their practice is as strong a silencing mechanism as the closet; indeed, I'm convinced that there is a connection between the "None of your business" that comes in response to a pushy asking of the price, and the "None of your business" that greets a candid question about sexual identity. I wonder what critics would write about, and how they would write, and what new styles and situations they might explore, if the hunger for status and security did not so hobble them. I can only be excited by the prospect of the manifold forms—direct, ornate, guttural, crude, labyrinthine, gnomic, interminable, minuscule—that critical endeavor might begin to take when intellectual curiosity no longer has to take the form of obeisance, and a grim-lipped, resigned pursuit of accreditation. One of the best teachers I ever had said, "Always ask the questions you really want the answers to." Never fake an interest. Never simulate curiosity. What are the questions we might begin to ask, as critics, when internecine combats over legitimation cease? I can't foresee such a utopia.

Resisting the Dangerous Journey: The Crisis of Journalistic Criticism

Michael Brenson

W hen an art critic learns that another art critic is going to make a public statement about art criticism, the first response is likely to be not eagerness and curiosity but an irritated and sightly paranoid, Uh oh!* Am I going to be attacked? Who is that critic to assume a position superior to mine? Who is he or she to make a claim for the special urgency or truth of his or her perspective? Since almost every critic feels some dissatisfaction all the time with the general state

*This essay began as the public lecture for the Doris Sloan Memorial Education Symposium at the University of Michigan Museum of Art, Ann Arbor, Nov. 12, 1994. It was delivered again at Brandeis University, Nov. 15, 1994, then revised for a lecture at the New York School of Drawing, Painting and Sculpture, Jan. 4, 1995. In April 1995, the talk was published by the Andy Warhol Foundation for the Visual Arts as Paper Number 4 in its Paper Series on the Arts, Culture and Society. This essay is an abridged version of that paper.

of art criticism but almost no critic discusses it except among friends, what right does any critic have to make his or her dissatisfaction known?

In the last few years this unofficial conspiracy of silence among critics about other critics has damaged the profession. It is based not on mutual respect and support but on self-protectiveness and laziness. It has discouraged an essential discussion of the responsibilities of critics to face issues, including the issue of criticism, and the consequences of not facing them. I believe that art criticism is failing miserably to meet the challenges of this time, and that art and artists, and indeed the artistic culture of this country, are suffering as a result. American art, artists and art institutions are struggling, and because so few critics have been willing to participate in this struggle and examine their role in its development and outcome, art criticism, as a whole, is in trouble.

It is not just the silence within the profession that distresses me but also the silence outside it. I made the decision to formulate a public statement about criticism last spring, at the end of yet another art season that featured an abysmal lack of critical vision and nerve and an unwillingness, almost across the art-world board, to utter a peep of protest. I am sick of people saying in private what they will not say in public, or saying in private the opposite of what they say in public. Part of what I admire in the writings of a public intellectual like Henry Louis Gates, Jr., is that there seems to be no real split between what he will

say privately and publicly. The institutionalization of private outrage and public silence—not just regarding criticism but also with regard to so much that matters to art and culture, including the now all-but-official hostility to art and demonization of the artist in America—has historical associations that are very disturbing to me. So much public silence in the face of so much private unhappiness throughout the art world is a sign of a crisis of moral imagination that is one of the underlying themes of this discussion.

What compels me is not the entire field of art criticism. I am not going to discuss critical theory and cultural criticism. The far-ranging investigations of art in terms of race, gender, and class need and receive their own forums. Analyses of, and meditations on, the definitions of art in a post–Cold War, postcolonial world, of the roles art has played in the formation and development of American society and of other societies around the globe, and of the social and political values art and criticism have consciously or unwittingly supported, are invaluable. The investigation of the assumptions and implications behind the words we use and the art we defend and the forms in which our words appear is particularly useful now in a world changing with such startling speed. Look at South Africa, look at Jordan and Israel, look at Eastern Europe. Look at the women's, black, and gay liberation movements within the United States. The views of art of many Americans were largely defined in a Cold War era that was governed by one or two points of

view, a will, and indeed often the sense of an obliga-
tion, to impose that "good" point of view, and a be-
lief, still obviously irresistible to many Americans, that
civilization itself can survive only if one particular
system of values is affirmed at home and abroad. The
radical shifts we have been living through in perspec-
tive, possibility, and power *have to* affect the produc-
tion and reception of art. Perhaps critical theorists and
cultural critics can't help with this fundamental ques-
tion: How do we deal with the wall between post- and
pre-Freudians? In other words, how do people who
take for granted that human beings are shaped by
assumptions and attitudes of which they are uncon-
scious when growing up, and who believe that free-
dom and morality depend on becoming aware of and
transcending these assumptions and attitudes, nego-
tiate relationships of justice and power with people for
whom the unconscious does not exist? But with all the
insularity of their language, and with all their some-
times alarming distance from, or indifference to, the
concrete living process of making and experiencing
art, critical theorists and cultural critics are doing a
far better job considering the challenges of this time
than the kind of criticism with which I am concerned
here.

The field in crisis is journalistic art criticism. This
is the one field of criticism that belongs to everyone
and touches personally a broad cross-section of curi-
ous and interested people. It also sets the tone for the

way America thinks about art. Yet largely because of its identification with the impersonal and mysteriously powerful news media institutions in which it appears, it is also the one field of criticism that seems essentially untouchable and unaccountable. Its enormous influence is taken for granted, particularly among artists, curators, and dealers in New York, yet general discussions about it rarely take place, and within the academic world only the most generous scholars treat it with respect. It may be both the most accessible and the most remote, the most wooed and the most spurned, field of criticism. I want to suggest the value of studying journalistic criticism. I also want to suggest the danger of continuing to exclude it from the essential theoretical and cultural conversations.

My focus here will be the art criticism that appears in daily or weekly large circulation national publications like the *New Yorker*, *Time*, *Newsweek*, *New York* magazine and the *New York Times*. My concern here is with *national*, not local, publications, although many of the problems are now endemic to the field.* No

*I have a great deal of admiration for local critics in New York and in other cities, some of whom have been writing with commitment and flair for a long time. But local critics have limited readerships, and most are responding to the needs of a very particular public. In addition, local critics write primarily reviews, and the review format has become too predictable, too formulaic, too safe, to make journalistic criticism effec-

matter how good the work of local critics may be, criticism in national publications leads the field of journalistic criticism in a way that criticism in local publications can't. The *Times*, the *New Yorker*, and *Time* have the greatest visibility, but critics for any number of national publications, including the *Washington Post*, the *Wall Street Journal*, and the *Los Angeles Times* have the ability to move the field. The way an artist or a trend is written about in any of these publications, particularly the *Times*, the *New Yorker*, *Time*, and *Newsweek*, can be taken by other newspapers and magazines not only in America but sometimes even abroad as a sign of the way that artist or trend deserves to be dealt with. One negative review in the *Times* made collectors cancel orders to buy an artist's paintings. Another made an institution halfway around the world think twice about taking the exhibition that was panned. A review I wrote for the *Times* on a public art project got waved around at a board meeting by the enraged director of a prominent cultural organization who did not like the project and who changed the organization's arts policy partly as a result of the visibility of my laudatory words.

Given their influence not only on art but also on the perception of art by people in power, what does it mean when the publications that have the ability to set the agenda for journalistic criticism reduce their

tively responsive to such an unpredictable, non-formulaic time.

art coverage and communicate little sense of mission in what they do cover? What is the effect on the field when the critics writing for these broad-based national publications, all of them with real strengths, some with impressive talent, seem to have almost no desire to engage the most pressing issues of their time and, in the process, to argue tirelessly that art is indispensable to the life of the spirit and to the forever unfinishable process of figuring out who Americans are individually and as a nation?

What happens when the criticism in these publications is almost entirely confined to reviews? Art reviews are indispensable. They are ways of recognizing and following artists, of keeping in touch with the changing ways artists think and of the ways artists, dealers, curators, and collectors function, of bringing new institutions and alternative spaces to public attention and tracing their rise or fall. They are ways for critics to evolve new ways of defining and thinking by finding out where their areas of ignorance and blindness are and working on them. Reviews continue to be written with purpose and punch, but there are now too few of them for journalistic criticism to be sufficiently grounded in the processes and textures of art. And reviews alone can never be enough. Reviews cannot substitute for essays in which critics put ideas together and grapple with the currents and pressures of the moment. These essays are rarely written anymore. When the number of reviews diminishes, when the reviews that do appear tend to focus on estab-

lished artists and entrenched institutions, and when almost every life-and-death artistic and cultural issue is denied or ducked, journalistic criticism begins to be experienced not as an attempt to explore and grapple with the challenges of contemporary art and life but as a way of avoiding them.

Look at the response to the crisis of the National Endowment for the Arts, which is far and away the most important artistic and cultural issue in America during the last five years. I believe strongly that the national journalistic critic's failure of vision and nerve in the face of the Endowment crisis goes to the heart of the current crisis of vision and nerve in journalistic criticism. The Endowment crisis is the one point of intersection for almost every major artistic cultural issue with which we are faced. It is there that the quality issue, issues of sexuality and race, the conflict between post- and pre-Freudians, and the predicaments of art institutions run together. The place of art and the artist in America cannot be understood apart from the Endowment crisis. Only through this crisis is it possible to measure our artistic and cultural resolve as a nation.

Who feels from the journalistic critic's coverage of this crisis that it is possible to figure out why the Endowment matters so much, what the implications of this crisis are, and what the changing role of the Endowment should or can be? In what publication have you seen an awareness of the number of first-rate small art organizations throughout this country that

will die if the Endowment is bled to death or dismantled? Just where have critics been trying to come to terms with the radically changing nature of arts patronage and the effects this will have on the life of art in this country? The entire middle ground of funding, which was partially provided and in an essential way symbolized by the NEA, is dropping out. What is likely to remain is private patronage, supporting blue-chip art, on one side, and foundation patronage, which is lining up behind art with an activist agenda, on the other. And where are the critics with the journalistic sense to immediately confront those controversial projects funded with small amounts of NEA money, like the Ron Athey performance in Minneapolis and the "Art Rebate" project in San Diego, that have so much to tell us about art and culture now, and the complex relationship between art and the rest of society so many artists are now trying to understand?

If critics lived the Endowment drama, I might not be asking these questions: Who feels from reading journalistic art criticism that the problems of our art institutions and their relationship to diminishing economic resources, changing funding sources, changing demographics, and changing social realities have been sufficiently articulated that we can create a public dialogue about the future of art museums in America? Who, among journalistic critics, is trying to think through in public the cultural and aesthetic consequences of the fundamental collision between art made by solitary artists inventing their own commu-

nities and worlds, and art made by artists determined to strengthen the traditions and authority of actual communities, many of them outside power? Which national journalistic critics consistently enter the terrain of art that makes them uncomfortable and write about it in ways that encourage emotional and intellectual risk?

I know very well the difficulties of being a journalistic critic. I know how hard it is to write seriously week in and week out for a mass-media publication. But I also know that the impossibility of journalistic criticism is proof of its necessity. I know as well that writing for a powerful newspaper or magazine with a general readership is an extraordinary privilege. And that before these regular writing positions are stepping stones to personal comfort and power, they are public trusts. I don't think readers look to newspaper and magazine critics for definitive answers. What they have a right to expect is full engagement, and full respect for how much their words affect the situation of art in this country. I know, too, that no matter how hard any institution may make it for them to do their jobs as they may want to do them, critics are fully responsible for the work they produce, just as artists are fully responsible for their art, no matter what kinds of pressures critics, collectors, and commercial galleries put upon them.

What makes it so difficult for me to watch journalistic criticism discredit itself is that it is irreplaceable. Critics writing for these general publications

have a special, if not a unique, opportunity to respond to the immediacy of art and communicate the power images and objects have. A good wordsmith, like Robert Hughes of *Time*, John Russell of the *Times*, Peter Plagens of *Newsweek*, or Kay Larson, formerly with *New York* magazine, can paint a vivid picture of what it is like to be present when the work of an Old or modern master, a Titian, a Poussin, a Manet, a Monet, a Picasso, a Brancusi, or of any of the first-rate contemporary painters and sculptors rooted in these traditions, begins to speak. Their writing can be beautifully concrete. While critical theorists and cultural critics have a tendency to respond more to the prevailing conventions of their discourses than to the living textures and personalities of art, journalistic critics can make their words quiver with the spark that makes a particular work of art live.

Journalistic critics can perform a great service by locating and preserving the delicate relationship between art and language that is one of the core issues of my life. As an intellectual, I believe that nothing can be allowed to be off limits to the most rigorous analysis. As soon as you place any response or assumption beyond analysis, or allow any subject, even one that has to do with religious faith, to be immune to critical intelligence, you allow it to become a taboo around which all sorts of fears and prejudices eventually stick and breed. But I also respect faith. And I understand in my bones the limits of analytical language and the ways it can resist, if not betray, the multilayered con-

creteness of experience. I hope I will always defend the most fearless questioning, but I also understand the words of Helena Luczywo, the coeditor of the Polish newspaper *Gazeta Wyborcza*, in Eva Hoffman's book *Exit into History*: "I don't believe in this American system of endlessly talking about everything," she said. "That's not what it's about, anyway."* I respect both the side of contemporary art that is struggling to bring centuries of assumptions and bias to the surface, and I respect the side of contemporary art that is struggling to communicate an experience that remains stubbornly resistant to words. I feel the power of words both when they name the unnameable, and when they hold within them the revelation of a mystery beyond language.

Two of the writers who left a permanent mark on me in the sixties were James Baldwin and Joan Didion. Their prose in *Notes of a Native Son*, *The Fire Next Time*, and *Slouching Towards Bethlehem* had an intense immediacy for me, and a rhythm that rolled their ideas through my head in such a prophetic way that they are circulating there still. A number of their essays first appeared in journalistic publications. I read Baldwin's *Fire Next Time* in the *New Yorker*. Didion has been as comfortable in the *New York Times Magazine* and *Book Review* as she has in the *New York Review of Books*. Their essays continue to be reminders

*Eva Hoffman, *Exit into History* (New York: Viking, 1993), p. 42.

for me of how the pressures and timeliness of journalism can inspire physical, insight-filled, nearly indestructible prose that looks at reality with unblinking poetic eyes.

At the same time that I first read Didion, I saw on the back cover of a book of Chekhov stories a statement I've never forgotten. It said that in his stories Chekhov held life, like a fluttering bird, in the cup of his hand. Substitute art for life and language for the hand and you will have a sense how precious the relationship between art and language can be for me. If the hand does not make the bird feel welcome, it will fly away; if the hand squeezes the bird too tightly, it will smother. Even if the hand does make the bird welcome, it will eventually leave, but its imprint, the sensation of what it felt like, will be written into that hand forever. The kind of writer who loves art and encounters actual objects every week has a better chance of sustaining this privileged partnership between art and language than someone whose experience of art is largely mediated by books and slides.

Journalistic critics can do much more than keep a respect for the vividness and concreteness of aesthetic experience alive. Because they are writing for publications that reach out to a general audience, they have an opportunity to build bridges not only across many regions within the art world but also between the art world and the worlds outside it. In a fragmented society in which the tendency is to divide and subdivide and subdivide again, critics who have the opportunity

to write about many kinds of art, from many cultures, can make their columns platforms on which many different people can meet. Journalistic criticism can demonstrate the importance of crossover critics who can suggest the kinds of exchanges that are possible among different people, and the kinds of insight an exploration of any one culture can bring to the understanding of others.

In addition, journalistic critics can have a real effect. For many people outside the art world, mass-media publications are the only sources of information about art and artists. Critics writing for these publications can therefore affect the national experience of art in a way critics writing for specialized publications can't. If an article in an academic publication like *October* or *Critical Inquiry* or *Representations* considered one of the great issues of the day, for example, the plight of the NEA, it would be read only by an influential but very small readership, and it would take a long time, if ever, for its insights to filter down to the general public. If, on the other hand, an analysis of the NEA appeared in the *New York Times* or the *New Yorker*, there is a very good chance that most of the essential players—from artists to politicians to members of the National Council for the Arts, the board that governs the Endowment—would pay immediate attention.

If you think I am expecting too much of art journalism, please remember that Clement Greenberg, Harold Rosenberg, and Thomas Hess, the three major

forces in establishing art criticism as a serious enterprise in the United States, all established and sustained their voices in journalistic publications. They were passionate and articulate writers who had no trouble expressing themselves in *The Nation*, the *New Yorker* or *New York* magazine.* The fact that their words appeared on these pages was essential to the legitimization of American art and to the expectation of engaged criticism many people still bring to the publications they wrote for. No matter how threatened by introspection and ideas mass-media publications may now be, the responsiveness of these three critics to the excitement and challenges of art—and their awareness of what art and criticism need to do at any given moment to prove themselves worthy of national attention and respect—can remain a model for the seriousness and commitment with which journalistic critics should proceed.

In short, journalistic criticism has an essential role

*Obviously, *The Nation* occupies a very different place now than it did forty or fifty years ago, before the explosion of publications on artistic, literary or political culture, but it still has influence. Its current art critic, Arthur Danto, is the only critic writing for a national journalistic publication who is entirely comfortable with ideas. He has a curiosity rare in journalism and entertains artistic possibilities other journalistic critics turn their backs on. He is not interested in urgent engagement or in commanding attention. Could the art critic for this kind of weekly publication once again put pressure on the field? I don't see why not.

to play in the artistic and cultural life of America. When it is as disengaged and self-absorbed as it is now, the entire artistic enterprise is weakened. Fewer artists, dealers, museums, and alternative spaces are supported. Issues are not brought into the open, where a public conversation about them can take place, but allowed to fester. Suspicion of art and criticism of the kind that has been unmistakable in government and on *60 Minutes* and in the magazine and news of the "Week in Review" sections of the *New York Times* snowballs.

It is not my purpose here to explore all the reasons for the crisis in journalistic criticism, but I will mention a few. Certainly, in a country in which social prestige and journalistic space can be largely determined by economic success, the weakening of the art market in the late eighties is a factor. Less money lavished on art means less respect and space for it in daily and weekly publications. It is also important to recognize that mass-media institutions are increasingly run by men and women groomed on the glitz and glamour of the eighties who are insensitive to the difference between real and ersatz culture, and who think of art and criticism, and indeed probably of all cultural pursuits, not as a calling but as a career. Obliteration of cultural memory is seen as indispensable to hipness. No one running any national mass-media publication seems to have any knowledge of, or interest in, how recent the success of art in America has been and how fragile the situation of the artist in

America is. My father was a modernist painter. I was brought up in the forties and early fifties, when to be an unconventional artist in America was to be a non-person. No one should forget that at that point, just after World War II, American modernism was barely appreciated, and hardly a single American painter was known abroad. In the fifties, the situation changed, in part because of the economic boom, in part because the government began to see a way to use adventurous art as a Cold War weapon. In the sixties, the National Endowment for the Arts formalized government support, and the American artist became a star in the international cultural arena. No one should ever take the place of the artist in America for granted. It has to be thought and rethought constantly. It has to be fought for again and again and again. It would be extremely unfortunate if this fight ceased to be part of the journalistic critic's job, and privilege.

In considering the current situation of journalistic criticism, it is also worth noting that not one of the critics writing for a national publication wants to be known exclusively as an art critic. Peter Plagens of *Newsweek* is a painter. Mark Stevens, who took over as the art critic of *New York* magazine in the spring of 1994, is also a novelist. Robert Hughes of *Time* has written significant books on nonart subjects, almost all his ambitious articles appear outside *Time*, and for a good while now his primary energy has gone into a television series on the history of art in America. Michael Kimmelman came to the *New York Times* as

a full-time music and part-time architecture critic and
has been writing regularly on music for *Vogue*. Adam
Gopnik of the *New Yorker* has made it clear that he
wants to be known as a man of letters. Among these
critics, only Plagens feels that the messy, uncertain,
conflicted arena of contemporary art is not something
foreign, something other, but his world. In not one of
these critics is there now the full commitment to be-
ing an art critic that the current challenges of art
criticism demand.

It is also important to recognize that facing these
challenges can put critics in difficult positions. Art
criticism was defined as a subject of significant con-
cern in national magazines and newspapers during a
postwar modernist era that assumed that a critic from
one viewpoint could effectively evaluate all art, and
that making judgments was the primary purpose of
the critic. The review format was designed for cover-
age of the monographic exhibition, or of the group
exhibition with one theme. When I think of the jour-
nalistic format, I think of a review of Vincent van
Gogh, or Lucian Freud, or Impressionism. I think
first of all of painting, in other words of a medium on
the wall so familiar that the public assumes it can be
taken in quickly, from one point of view, directly in
front of it, like a reader scanning a newspaper, or a
viewer absorbing a few seconds or minutes of enter-
tainment on the television screen. I also think of a
characterization of an artist or a body of work, or a
commentary on an exhibition's point of view, or an

evaluation of historical influence and ultimate achievement. The format and procedures of journalistic criticism are highly conventionalized. The critic writes in an authoritative tone, on a subject assumed by institutional consensus to be worthy of his or her attention, and the institutions of the publication, the museum, and the journalistic critic are strengthened as a result. A review may be misguided or superb; and an eloquent review can be so sharp or give so much pleasure that it may be unforgettable. My point is that for a long time, the form of the review, the subject of the review, and the needs of the news institution to attend to culture while reinforcing its own authority, appeared to be a seamless fit.

Where journalistic critics have traditionally had the most trouble is precisely in those areas where categories blur or borders are crossed, which happen to be the areas in which some of the most important art and thinking of this decade is taking place. The nineties are full of projects that challenge traditional definitions of art. That challenge traditional art boundaries. That make it hard to say, this and only this is what art is, here and only here is *where* it is.

I want to give you an example of the kind of art with which daily and weekly journalism has the most serious trouble. In 1993, David Avalos, Elizabeth Sisco, and Louis Hock, three artists in San Diego, conceived a performance piece called *Arte-Reembolso/Art Rebate*. It included giving fresh $10 bills to 450 illegal aliens who had crossed the border into the United States. The

$5,000 for the piece was provided by San Diego's Museum of Contemporary Art, a mainstream museum, and the Centro Cultural de la Raza, a community arts center, as part of their collaborative exhibition "La Frontera/The Border." It included more than thirty artists, some as well known as Terry Allen and Luis Jiménez, who have lived along the nearly 2,000-mile Mexican–American border, and whose work is partly or wholly inspired by its collision of cultures and ideas. Because one third of the funding for "La Frontera" was provided by the National Endowment for the Arts, giving money to illegal aliens was explosive. In his front-page article on *Art Rebate* in the *Times*, Seth Mydans spoke with the artists; he quoted Representative Randy (Duke) Cunningham of San Diego—who said, "I can hardly imagine a more contemptuous use of taxpayers' hard-earned dollars"—and he spoke with officials of the Endowment, which, as a result of the project, was yet again under siege.* Many people reading about the project were furious. Such a piece always triggers the reactions: What does this have to do with art? It's nothing but a cut-and-dried, self-serving political act. I remember saying to myself when I read Mydans's article, "Damn it! Why do a project like that now, when the Endowment is so vulnerable," but I reserved judgment because I know very well that this is precisely

*Seth Mydans, "Art Dollars for Me, $10 for You, $10 for You," *New York Times*, August 12, 1993, A:1.

the kind of work that is never reported in a way that makes it possible to really understand it. Three days after the first Mydans article, the *Times* produced a Sunday editorial that characterized the three artists as "loonies."*

Let me comment a bit about the piece and its implications. One: As many of you know, the Mexican–American border can have a stark, often nightmarish, sometimes hallucinatory reality. As some of you are aware, the border has also become a concept that is crucial to the art of this time. Borders are bitterly contested all over the world, including the Middle East and Eastern Europe. The authority and permeability of borders between classes, between races, between neighborhoods, between the post-industrial and pre-industrial worlds, is an essential issue of contemporary life. The Mexican–American border is now both an actual region and a symbol through which many people believe it is possible to experience and visualize the kinds of hybrid identities and creations emerging from border conflicts and collisions. By the vehemence of the responses it evoked, and by the sharp difference in the responses of Chicanos and whites, *Art Rebate* underlined both the urgency of the real situation the exhibition "La Frontera" was trying to deal with, and the importance of the border as symbol. Two: Avalos, Sisco, and Hock wanted to make

*"Watch This Intellectual Space," editorial, *New York Times*, Aug. 15, 1993, p. 14.

a statement about the ambiguous and complex situation many illegal aliens, or undocumented workers, are in. They pay sales tax on almost everything they buy in the United States, and for a long time they have enabled many people to get valuable labor for low wages without paying taxes, but they have no rights. They have been an important part of the California economy, and do a lot of work no one else there will do, but when the state needs a scapegoat, they are it. By giving a few hundred people a "tax rebate" of ten dollars that was clearly symbolic but also just enough to be significant, the artists helped call attention not only to the plight of illegal aliens but to an extremely ambiguous and complex *American* situation. Three: For many Chicanos, the idea of being alien in the southwestern United States is impossible to accept. They know that this part of the country belonged to Mexico until 1848. A recent poster by Yolanda Lopez, a Chicano artist living in San Francisco whose installations are intense responses to the experiences of loss and intimacy, shows a man in an Aztec headdress pointing out at us like Uncle Sam and saying, "Who's the illegal alien, *Pilgrim?*" Four: Letters about the project kept appearing for weeks in the San Diego papers. Many defined for Chicanos what other Americans thought of them. "They hate us," one Chicano art professional said to me. When Proposition 187 passed in California it institutionalized the vehement reaction brought to the surface in *Art Rebate*. The proposition calls for ending education and health

services to the children of illegal aliens. These services are seen as a serious drain on the fragile economy of California by many people in the state who are not anti-Chicano, including many African-Americans and legal immigrants. Five: The *Art Rebate* artists wonder why so many Americans complain about tiny amounts of taxpayer money given to a handful of controversial art projects while so few Americans voice outrage about vast amounts of taxpayer money wasted. Where, they wonder, is the righteous indignation about the savings and loan scandal and the billions of taxpayer dollars needed to deal with it?

However anyone may analyze *Art Rebate*, and big questions can be raised about it, I think you will agree with me that Avalos, Sisco, and Hock are not loonies. Would the *Times* use this word on its editorial page to describe serious people in any other profession?

What does *Art Rebate* have to do with art? For one thing, it increases the immediacy of "La Frontera" by letting everyone know artists making work about the Mexican–American border can be playing for high stakes. The piece has that sense of necessity, that rootedness in life-and-death issues, that characterizes much of the art that deserves attention. For another thing, the piece seems so logical and yet so unexpected that it suggests the kind of artistic imagination that can shed light on anything it touches. Finally, it creates an aesthetic space in the mind, in my mind anyway, where artists, politicians, north and south, United States and Mexico, the media and art, run

together. That space will remain active in me for some time.

Now I want to give you an example of how hard and fast categories and borders are in newspapers and magazines. On Aug. 25, 1992, *New York Times* music critic Allan Kozinn wrote a review of "The World of Richard Strauss," a two-weekend festival at Bard College that included an exploration of Strauss's connections with Nazism. Kozinn wrote of "pictures of Strauss and Goebbels beaming at each other, and Strauss conducting beneath a swastika banner. More broadly, the exhibition's posters vilify composers whose music, in the Nazis' view, did not represent pure German values and would corrupt the morals of children. Music lovers are exhorted to reject these dangerous currents and protest against them." Then Kozinn wrote this: "A visitor taking in the exhibition just two days after the Republican National Convention could not help but notice a similarity between this rhetoric and that of the American right wing. Such a comparison was clearly intended: an adjacent exhibition presented fifteen prints by Robert Mapplethorpe, the photographer whose work was a focus of the conservative attack on the National Endowment for the Arts."*

The next day, an editors' note appeared in the paper. It said this: "A music review yesterday described

*Allan Kozinn, "The World of Richard Strauss, Murky and Not So Honorable," *New York Times*, Aug. 25, 1992, C:13.

'The World of Richard Strauss,' a music festival at Bard College, which included a re-creation of a 1938 exhibition of Nazi propaganda against 'degenerate,' modern music. The review said there was a similarity between such propaganda and some views expressed at the Republican National Convention this month. Such an offensive comparison was out of place in a music review.*

This editors' note crystalized for me a number of attitudes shaping the *Times*'s cultural coverage. One was that critics should stay in their corners. The second was that the culture section had become essentially an adornment for the most important, the only *real*, parts of the paper, the hard news sections. It is there and only there that life-and-death issues can be dealt with. In most mass-media publications, there is a clear frame around columns of criticism, and critics must be careful not to trespass outside it. The note also drove home to me that within the most powerful mass-media institutions, individualism, and independence are welcome only within strict limits. Without room for individualism and independence to breathe fully, how much room can there be for the imagination?

Clearly, then, if a critic approaches unframable projects like *Art Rebate* with a curiosity and willingness to suspend judgment until the art has revealed

*Editors' Note, *New York Times*, Aug. 26, 1992, A:2.

what it has to offer, and then writes about it in a reflective and questioning manner, the criticism may challenge institutional frameworks and, by implication, institutional thinking. And this may put the critic at risk within the institution. Given the anger in that *Times* note, wariness about confronting some of the most serious and interesting art of the nineties in any large corporate institution is understandable.

But critics must ask themselves these questions: If I don't push the envelope and find some way to re-invent my profession so that it can continue to do justice to the issues shaping the art of my time, what am I doing? Am I doing my job? What effect will my lack of vision and nerve have on the attitude toward art and artists, criticism and critics, in this country? And what effect will my lack of vision and nerve have on the vitality of the institution I work for? Are critics really serving their institutions, or art criticism, not to speak of contemporary art, through unwavering obedience to institutional expectations that might be parochial, if not anachronistic?

I am definitely not saying a critic should consider a stupid and futile attempt to overturn his or her institution. I do think that if critics really love their institutions and believe in themselves, and see writing about art not as a career but as a calling, they will know they have to keep struggling to make their institutions dynamic. This cannot be done by hiding behind the institution. Nor can it be done without

making peace with the kind of uncertainty so many journalistic institutions consider a curse. The one response that is impermissible on the network news is doubt; permission to doubt is one of the great gifts of modernism to twentieth-century culture. Critics must be willing from time to time not only to wiggle their toes in issues that threaten them, or for which they have no answer, but to plunge into them and learn to swim there. It is impossible at any time for critics who write regularly to avoid mistakes. Making them and being attacked for them mean little or nothing in themselves. What matters is the way critics deal with these mistakes and attacks. What matters is the quality of curiosity, the quality of attentiveness, the quality of concern, the quality of vision, the quality of the experience of art and language. It is also the quality of debate a critic makes available. If the discussions provoked by a critic are at the expense of that critic, so be it. If I say something that unwittingly brings to the surface aesthetic or cultural or racial limitations, and my words enable people to become more aware of those limitations, fine. Probably everyone has a sense of the kind of critic needed to meet the challenges of this moment. Many approaches are, of course, possible. Many different approaches are needed. I am looking for critics who not only love art—not just one kind of art, but *art*—but also who love language, and who are also able to keep learning and growing from their mistakes, and from the dialogues they es-

tablish with and among their readers and within themselves.

I am also looking for critics whose imaginations let them know that they must reach out not only to art that responds to their taste but also to art that makes them afraid and to issues for which they have no answer. The best scholars, scientists, poets, and artists— the best people in any field—know that anytime you take on again and again and again an issue you felt you had no idea how to deal with until you begin to learn to deal with it, you change, you evolve, you grow, you set an example to those around you of the way knowledge and transformation happen. In one of the parables in his bleak, lush, grand novel *The Crossing*, Cormac McCarthy writes, "as has been the case with many a philosopher that which at first seemed an insurmountable objection to his theories became gradually to be seen as a necessary component to them and finally the centerpiece itself."* The Russian poet Marina Tsvetayeva said: "Don't forget that the apparent impossibility of something is the first sign of its naturalness—in a different world, naturally."† Well, we live in a different world every day, even in

*Cormac McCarthy, *The Crossing* (New York: Knopf, 1994), p. 154.
†Boris Pasternak, Marina Tsvetayeva, and Rainer Maria Rilke, *Letters: Summer 1926*, edited by Yevgeny Pasternak, Yelena Pasternak, and Konstantin M. Azadovsky (San Diego: Harcout Brace Jovanovich, 1985), p. 30.

our familiar world, and the world that awaits us at the dawn of the next millennium will have been unimaginable from the perspective of someone who thought he or she knew what the world was like in 1968 or even 1989, when the Iron Curtain collapsed.

So criticism for me is not a position but a way of being. It is a way of encountering and being encountered, a way of testing and being tested, a way of feeling blind and beginning to see, a way of learning to work with the knowledge that anxiety can be both your worst enemy and your truest friend, a way of being true to the past and open to the present and future, of being true to the past *by* being open to the present and future. Just as the measure of artists can be taken by their ability to struggle with problems that surface within their work, so the measure of critics can ultimately be taken by their ability to struggle with issues and ideas that at one time they had no idea how to deal with. Good artists may put something out in public they have not resolved, but they do not lie to themselves about it. They always know what they did not do and did not get, and they will not rest until they have dealt with what they left unresolved. Why should critics be different? Why should critics have more permission than artists to fool themselves? If critics know they didn't get something, or if they know they wrote something that exposed them to their own insecurity or ignorance, they had better, sooner or later, perhaps even much later if need be, deal with it.

The dangers of backing away from conflict can be suggested by the consequences of failing to deal with the crisis of the National Endowment for the Arts.* Time and again, the crisis put critics where they seldom are, on the national stage. It gave them a national platform, and almost all of them refused it. The influence of Robert Hughes and Hilton Kramer outside the art world has a lot to do with their grasp of the importance of this kind of opportunity and their ability to express ideas and opinions that make people feel they are not backing down from the challenges of their time. If critics do not grab this kind of opportunity when it presents itself, they will not be at the same place where they were before. Their place in society will be lower. The patronizing article aimed at critical jargon on the front page of the *New York Times* news of the "Week in Review" on October 30, 1994, is a sign of the current lack of respect for art criticism across the journalistic board. In my opinion, every journalistic critic who has avoided the Endowment issue has been compromised as a result. I also believe that the entire field of art criticism has paid a price for the lack of vision and nerve of national journalistic critics fleeing the Endowment challenge. I think it will take years for art criticism, as a whole, to recover from it. The Endowment crisis, and the response to it

*There certainly are journalistic critics in New York and around the country, like Amei Wallach of *Newsday*, who have made responsible attempts to cover this issue.

in journalistic criticism, should become a textbook for future generations of critics looking to define the critic's job.

James Baldwin, like so many influential writers and artists, believed it was his responsibility and privilege to search and to struggle. While living in France and talking to his biographer David Leeming about what it would mean for him to avoid going back to America, he made a remark that is good advice for critics: "I've always felt that I had no real choice about the journey," Baldwin said. "In a way I learned about it in the streets. If you're frightened of something in the streets you walk towards it. Turn your back and they've got you."*

I want the last word here to go to Toni Morrison, whose short book of essays *Playing in the Dark: Whiteness and the Literary Imagination* was very much on my mind when I began thinking about this talk last summer. Morrison believes in the necessity for artists to go where their imaginations lead them. When they do follow their imaginations, which have their own needs and wills, they may enter unexplored land, and as they write their way through it they may locate and define areas within a culture that were silent or invisible before. In the course of her discussions of Poe and Hemingway and other American writers, she raises the absolutely crucial question of the link between the

*David Leeming, *James Baldwin* (New York: Knopf, 1994), p. 256.

creative imagination and moral courage, a link that now demands our fullest attention. She ends her first essay articulating the racial assumptions responsible for the irresolutions in Willa Cather's last novel, *Sapphira and the Slave Girl*. She talks about Cather's "valiant effort at honest engagement" and praises her courage to enter a territory she could not yet chart.*
"In her last novel," Morrison writes, Cather "works out and toward the meaning of female betrayal as it faces the void of racism. She may not have arrived safely, like Nancy, but to her credit she did undertake the dangerous journey."† There is respect and perhaps even love in the words "to her credit she did undertake the dangerous journey." I am sure there are critics for whom these words can be inspiration and guide.

*Toni Morrison, *Playing in the Dark: Whiteness and the Literary Imagination* (New York: Vintage, 1993), p. 19.
†Ibid., p. 28.

Making Movie Magic

bell hooks

Movies make magic. They change things. They take the real and make it into something else right before our very eyes. Usually when I critique a movie lots of folks like they tell me, "It was just showing the way things are. It was real." And they do not want to hear it when I make the point that giving audiences what is real is precisely what movies do not do. They give the re-imagined, re-invented version of the real. It may look like something familiar, but in actuality it is a different universe from the world of the real. That's what makes movies so compelling. Talking about the need for an "aesthetic ecology" wherein the artistry of films is not submerged by any other agenda, visionary filmmaker Stan Brakhage shares this insight: "All this slavish mirroring of the human condition feels like a bird singing in front of mirrors. The less a work of art reflects the world the more it is being in the world and having its natural

being like anything else. Film must be free from all limitations, of which the most dangerous is the imitation of life."

Most of us go to movies to enter a world that is different from the one we know and are most comfortable with. And even though most folks will say that they go to movies to be entertained, if the truth be told, lots of us, myself included, go to movies to learn stuff. Often what we learn is life-transforming in some way. I have never heard anyone say that they chose to go to a movie hoping it would change them utterly—that they would leave the theater and their lives would never be the same—and yet there are individuals who testify that after seeing a particular film they were not the same. Much of what Jeanette Winterson attributes to the power of the literary texts in her collection *Art Objects: Essays on Ecstasy and Effrontery* is equally true of cinematic narratives. She contends: "Strong texts work along the borders of our minds and alter what already exists. They could not do this if they merely reflected what already exists." As cultural critics proclaim this postmodern era the age of nomadism, the time when fixed identities and boundaries lose their meaning and everything is in flux, when border-crossing is the order of the day, the real truth is that most people find it very difficult to journey away from familiar and fixed boundaries, particularly class locations. In this age of mixing and hybridity, popular culture, particularly the world of movies, constitutes a new frontier providing a sense of

movement, of pulling-away from the familiar and journeying into and beyond the world of the other. This is especially true for those folks who really do not have much money or a lot of time as well, as for the rest of us. Movies remain the perfect vehicle for the introduction of certain ritual rites of passage that come to stand for the quintessential experience of border-crossing for everyone who wants to take a look at difference and the different without having to experientially engage "the other."

Whether we like it or not, cinema assumes a pedagogical role in the lives of many people. It may not be the intent of a filmmaker to teach audiences anything, but that does not mean that lessons are not learned. It has only been in the last ten years or so that I began to realize that my students learned more about race, sex, and class from movies than from all the theoretical literature I was urging them to read. Movies not only provide a narrative for specific discourses of race, sex, and class, they provide a shared experience, a common starting point from which diverse audiences can dialogue about these charged issues. Trying to teach complicated feminist theory to students who were hostile to the reading often led me to begin such discussions by talking about a particular film. Suddenly students would be engaged in an animated discussion deploying the very theoretical concepts that they had previously claimed they just did not understand.

It was this use of movies as a pedagogical tool that

led me to begin writing about films as a cultural critic and feminist theorist. Centrally concerned with the way movies created popular public discourses of race, sex, and class, I wanted to talk about what these discourses were saying and to whom. Particularly, I wanted to interrogate specific films that were marketed and critically acclaimed as progressive texts of race, sex, and class to see if the messages embedded in these works really were encouraging and promoting a counterhegemonic narrative challenging the conventional structures of domination that uphold and maintain white supremacist capitalist patriarchy. Even though many traditional academic film critics are convinced that popular art can never be subversive and revolutionary, the introduction of contemporary discourses of race, sex, and class into films has created a space for critical intervention in mainstream cinema. Often multiple standpoints are expressed in an existing film. A film may have incredibly revolutionary standpoints merged with conservative ones. This mingling of standpoints is often what makes it hard for audiences to critically "read" the overall filmic narrative. While audiences are clearly not passive and are able to pick and choose, it is simultaneously true that there are certain "received" messages that are rarely mediated by the will of the audience. Concurrently, if an individual watches a film with a profoundly politically reactionary message but is somehow able to impose on the visual narrative an interpretation that is

progressive, this act of mediation does not change the terms of the film.

A distinction must be made between the power of viewers to interpret a film in ways that make it palatable for the everyday world they live in and the particular persuasive strategies films deploy to impress a particular vision on our psyches. The fact that some folks may attend films as "resisting spectators" does not really change the reality that most of us, no matter how sophisticated our strategies of critique and intervention, are usually seduced, at last for a time, by the images we see on the screen. They have power over us and we have no power over them.

Whether we call it "willing suspension of disbelief" or just plain submission, in the darkness of the theater most audiences choose to give themselves over, if only for a time, to the images depicted and the imaginations that have created those images. It is that moment of submission, of overt or covert seduction, that fascinates me as a critic. I want to critically understand and "read" what is happening in that moment, what the film tries to do to us.

If we were always and only "resisting spectators," to borrow a literary phrase, then films would lose their magic. Watching movies would feel more like work than pleasure. Again and again I find myself stressing to students, to nonacademic readers, that thinking critically about a film does not mean that I have not had pleasure in watching the film. Although the movie annoyed me intensely, I enjoyed watching

Quentin Tarantino's *Pulp Fiction*. I left the theater at midnight, came home, and sat writing into the dawn. My hands were cold, as the heat in the building had long since been turned off. My feet were numb, but as long as I was writing I did not notice. I was trying to capture the fierce intense impressions the film had made on me. It's awesome when a creative work can charge my critical batteries in this way.

Rarely do I write about work that does not move me deeply. And I hate to write about a film when I think it's just "bad." There are two exceptions in this collection. Larry Clark's *Kids* did not move me at all; it enraged me. And because so many progressives critiqued the work in discussion but did not want to go public for fear of censure, I decided to write an essay. *Waiting to Exhale* is the one bad movie I write about. It is not bad because of the genre. There are some great popular films made solely to entertain, and this is not one of them. I chose to write about *Waiting to Exhale* as a way to critically reflect on the notion of "black film," to critically examine the way blackness as commodity is appropriated by mainstream media and then marketed as fictive ethnography, as in "this is about black life."

At its best, cultural criticism of movies illuminates, enabling us to see a work in a new way. It enhances the visual experience. Quentin Tarantino is fond of declaring: "If I wasn't a filmmaker, I'd be a film critic. . . . I would rather get a well-written, thoughtful review, even if it be negative than a badly written

gushy review. If they're coming from somewhere, that's interesting, it's all food for thought." The critical essays I have written on films usually provoke and cause a stir precisely because I write about work that has passionately provoked and engaged me. Spike Lee has done many films since *She's Gotta Have It* came out in 1985, but what a stir that picture caused. At the time, it was really remarkable that a black male filmmaker was perceived as offering a vision in cinema of a sexually liberated black woman. This film generated more discussions of the politics of race and gender, of rape and violence against black women, than any feminist article or book on the subject at the time. Naturally, I was moved to write a critical piece. This was the first essay I had ever written about a film. It was called " 'Whose Pussy Is This?' A Feminist Comment." Published first in my column in the left magazine *Z*, it reached audiences both inside and outside the academy. Later I included it in *Talking Back*, my first collection of essays. It became the most xeroxed, the most talked-about piece, serving as a critical intervention challenging viewers to look at the film in a new way. To be honest, I was stunned by the feedback. Not only was I awed by the way folks managed to get a hold of this piece, I was moved on hearing story after story about the intense discussions that followed a viewing of the film when audiences had also read the essay.

I kept waiting for a Spike Lee film that would really have a complex awareness of sexual politics. Finally,

after eight films, he made *Girl 6*. Ironically, many critics missed the shift in perspective in this movie. Unlike Lee's other work, this film critically examines sexism and misogyny. Excited to see the influence of feminist thinking, I was shocked that so many viewers failed to grasp this shift and decided it was necessary to write a feminist critique celebrating and exploring this change.

As a critic who has always worked to address audiences inside and outside the academy, I recognized that oral critical discussions of films took place everywhere in everyday life. Across class, race, sex, and nationality, people would see a film and talk about it. As a black woman intellectual working overtime to call attention to feminist thinking, to issues of sexism, one who wanted to talk about the convergence of race, sex, and class, I found films to be the perfect cultural texts. I was particularly pleased to have the opportunity to write about Atom Egoyan's work because I had been a fan of his films since the beginning. When *Exotica* was made it was exciting to see that an interesting independent filmmaker could make a work that proved to have such wide appeal. Then there is Isaac Julien's short video/film *The Attendant*. When I showed it to my class of women students at City College, who were reading the essays of cultural critic Stuart Hall, they felt that they just could not grasp what was happening. I wrote this essay for them and for everyone else who wants to have a way to think about this film. Similarly, I was moved to write

about the connections between eroticism and death in Mike Figgis's recent film *Leaving Las Vegas* because of the ways that film speaks to the issues of power and desire, pleasure and danger, reconfiguring tropes of female masochism in ways that may or may not be liberatory.

Seeing movies has always been a passion in my life. When I first met movie "aficionado" A.J.—Arthur Jaffa (a director and cinematographer)—he was pretty amazed that I could name and had seen movies he did not know about and vice versa. Some of the flavor of our ongoing dialogue is captured here in the critical conversation we have about film. This project began when Caleb A. Mose asked us both to come and be interviewed for a film he was making. This dialogue was spontaneous—unstructured. It was different from an interview. When I interviewed Charles Burnett, Julie Dash, Camille Billops, and other film-makers, I went to them with a set of specific questions that formed the basis of our discussions. With Billops I wanted to talk about the place of confession and the autobiographical, with Dash her use of archival material and ethnographic research. Individuals who love Dash's *Daughters of the Dust* may have read our conversation in the book that focuses on the film.

When the subject is race I am particularly concerned with questions of race and black liberation. When I write critical essays on the work of black filmmakers, I reflect on the issue of aesthetic accountability and how the burden of representation informs

this work. Exploring the issues of resisting images, I raise questions about what is required to imagine and create images of blackness that are liberatory. Changing how we see images is clearly one way to change the world. The work of black filmmakers receives much attention in my work precisely because the multiple narratives it constructs revitalize contemporary critical discussions of the way blackness is represented and seen in this society. Despite progressive interventions (there are certainly more black filmmakers making films, both Hollywood and independent films, than ever before), there have not been sustained major visual leaps in the nature of black representation. Concurrently, the essentialist belief that merely the presence of larger numbers of visible black filmmakers would lead to a more progressive and/or revolutionary cinematic representation of blackness has been utterly challenged by the types of films that are being made.

In keeping with the critique of essentialism suddenly we are compelled to think more deeply about the standpoint of the black filmmaker. Interviewing Isaac Julien after the premiere of his feature film *Young Soul Rebels*, we spoke about the ways black audiences can be as uncomfortable with diverse and/or radical representations of black subjectivities as any other group. Julien reminded us then that "blackness as a sign is never enough. What does that black subject do, how does it act, how does it think politically? . . . Being black isn't really good enough for me: I want to know what your cultural politics

are." The interrogation of the very sign of blackness by contemporary left cultural workers ruptured the critical complacency surrounding fixed assumptions about the black aesthetic that had for the most part constituted the conceptual framework within which most critical writing by black thinkers about film took place.

Often the new critical writing done by folks, like myself, who are not traditionally trained as film critics is viewed suspiciously. Indeed, our work interrogates the very assumptions about the nature of black representation that a preexisting body of film theory had helped to put in place and sustain. In the essay "What Is This 'Black' in Black Popular Culture?" Stuart Hall defined the subversive standpoint as one that refuses to see everything via the logic of binary opposition: "The essentializing moment is weak because it naturalizes and dehistoricizes difference, mistaking what is historical and cultural for what is natural, biological, and genetic. The moment the signifier 'black' is torn from its historical, cultural, and political embedding and lodged in a biologically constituted racial category, we valorize, by inversion, the very ground of the racism we are trying to deconstruct." Dialogues with black British cultural critics and filmmakers were important critical interventions. These discussions challenged us all to think differently about black identity, to more forcefully engage critiques of essentialism and to focus on diasporic representations.

For individual traditional black film critics and

many of us "new kids on the block" it was difficult to face that in some rare moments there were more progressive representations of blackness in the work of exceptional visionary white filmmakers (cultural workers like John Sayles and Jim Jarmusch) than in the work of individual conservative black filmmakers. Their representations of blackness, along with others, were the positive interventions providing concrete interrogative evidence that it was not so much the color of the person who made images that was crucial but the perspective, the standpoint, the politics. For so long most white filmmakers were interested in using black images only as a backdrop reinforcing racist paradigms that it was easy for a black essentialist aesthetic to emerge, since it appeared that most white artists were incapable of seeing blackness from a decolonizing standpoint. Now that more white filmmakers, both mainstream and independent, centralize black characters in films, diverse white perspectives and standpoints are more obvious.

Even though so much critical work has emerged in cultural studies and/or film studies interrogating old colonizing racial imagery, particularly the representation of blackness, creating new awareness of standpoint and accountability, some filmmakers still don't get it. Ironically, the focus on diversity has inspired some white filmmakers (for example, Quentin Tarantino and Larry Clark) to exploit mainstream interest in the "other" in ways that have simply created a new style of primitivism. While these filmmakers made use

of border-crossing and themes of cultural hybridity, they did not do so in any way that was particularly subversive and/or enlightening. My essays on Tarantino and Clark explore the ways transgressive imagery of a nonwhite "other" is used in the work of these filmmakers without challenging stereotypes or the existing structures of domination. All too often artists fear that thinking politically about their work will interfere with some "pure" vision. Yet it is this very notion of visual purity that is a distortion. We often have too narrow a notion of what it means to be political. Even though much of Stan Brakhage's work was very personal, in relation to gender he was making incredible interventions. This work was political. It was thrilling to hear Brakhage affirm that standpoint in the interview Suranjan Ganguly published in *Sight and Sound*, "All That Is Light." When asked to respond to critiques that his works are not that politically relevant, Brakhage insists that his works address sociopolitical realities emphasizing: "I think my films address that constantly. I don't think there has ever been a film that I wished to make that wasn't political in the broadest sense of the term, that wasn't about what I could feel or sense for better or worse from the conditionings of my times and from my rebellions against those conditionings." These issues are constantly relevant to black filmmakers, who are consistently made to feel that their work can have a profound meaning only if it is overtly political.

* * *

At different public events when questioned about either the homophobic images of gay characters in his films or the misogynist portrayals of women, filmmaker Spike Lee has mocked the issue of artistic accountability by suggesting he is merely documenting life "as is." His unwillingness to engage critically with the meaning and messages his work conveys (whether the content does or does not reflect his belief system) undermines the necessity for both critical spectatorship and critical thinking about representations. Certainly, everyone who has ever exploited depictions of racial stereotypes that degrade black people and perpetuate white supremacy could argue that they are merely showing life as is. Thinking in a constructive way about accountability never diminishes artistic integrity or an artistic vision, it strengthens and enhances.

Much of the magic of cinema lies in the medium's power to give us something other than life as is. I have written more critical essays about Spike Lee's work than about that of any other filmmaker. Often readers wrongly assumed I do not find his work engaging. Indeed, there is a magical moment in every film Spike Lee has made, and I am always eager to see the work, to see that moment. I tell audiences, particularly non-academic folks, when they question me about Spike Lee's work, that my desire is not to "trash" his work but to provide a critical perspective that could be useful to audiences and to him by enabling us to see Lee's work in new ways, to reimagine and reenvision.

Indeed, all my critical writing and discussions about films are meant to be constructive, to critically intervene in a way that challenges and changes. Movies do not merely offer us the opportunity to reimagine the culture we most intimately know on the screen, they make culture. With my writings about film, I intend to rigorously and playfully examine what we are seeing, ways we think about what we are seeing, and ways we look at things differently. My work interrogates even as it continually celebrates cinema's capacity to create new awareness, to transform culture right before our very eyes.

Measuring the Immeasurable

Sarah Rothenberg

"Is there a measure on earth?
There is None."

—Hölderlin

The Critic and the Reader

In 1892, just over a century ago, the great Czech composer Antonin Dvořák arrived on American shores, at the behest of the entreprenurial wife of a millionaire grocer, to take on the job of heading her new privately funded National Conservatory of Music in New York. One year later, on December 16, 1893, Dvořák unveiled the magnum opus of his American adventure, his "New World" Symphony. The event took place in Carnegie Hall, with Anton Seidl leading the superb New York Philharmonic. Henry Krehbiel reviewed the performance in the *New York Daily Tribune*.

Krehbiel's in-depth musical analysis of the work, based on the critic's attendance of an open rehearsal

and printed on the day of the official premiere "to enable those who shall hear the symphony . . . to appreciate its American character,"* is an unusually extensive piece by today's standards. But for American readers a century later, the most astonishing bit of cultural evidence from an earlier time is the use of musical notation: the article contains fourteen musical examples, with a total of eighty bars of music.

The presence of excerpts from an orchestral score quoted freely in a daily sold on streetcorners speaks eloquently of a defined relationship between critic and reader, composer and audience, producer and consumer. While Americans were, for the first time, quite self-consciously attempting to put a distinctly American imprint on the European tradition of concert music (for the issue of American identity was a large part of Dvořák's project in this country), there was, nevertheless, quite *un*self-consciously, an accepted notion of the relevance of such a discussion and an expectation of musical literacy for those who wished to enter into it.†

For the many centuries preceding the technological

*Henry Krehbiel, "Dr. Dvořák American Symphony," *New York Daily Tribune.* December 16, 1893.

†The assumption was unexceptional. H. L. Mencken, not a music specialist himself, offered his own views on the American character of Dvořák's symphony and challenged his readers: "If you don't believe it, get a good edition of the Jubilee Songs and the score of the symphony and go through them at the piano on some quiet Sunday afternoon."

revolution's introduction of transmitted and recorded sound into our daily lives, music could only be experienced in one of two ways: one made it oneself or one was in a room where someone else was making it. This was as true from the first primal utterance of song to the emergence of monastic chant, from Bach's church services in Leipzig to Mozart's opera houses in Vienna, from Brueghel's marketplaces to the dance halls of Toulouse-Lautrec, from Chopin's appearances in Parisian salons to Dvořák's symphony in Carnegie Hall. It was still true at the time of the world premieres of major works by Stravinsky, Schoenberg, and Bartok.

The nineteenth-century rise of the middle-class in Europe coincided with the development of an instrument for home use that would promote musical literacy among the bourgeoisie—the piano. As the first instrument of musical reproduction, the piano allowed for the musically curious to explore the full range of concert repertoire—orchestral, vocal, even operatic—in the privacy of their homes. Piano score arrangements were expressly produced for these purposes. Such piano reductions were the commercial equivalent of their later progeny, LPs and CDs, which would no longer demand musical literacy of their consumers.

In 1943, fifty years after the "New World" Symphony's premiere and in response to the growing popularity of the gramophone and the radio, Virgil Thomson predicted confidently that "processed" music, like "canned peaches," might be a "supplement to

fresh musical fare" but never its substitute. Despite the presence of "a radio in every home and in nearly every drug store," Thomson assured his readers that home piano sales were still on the rise, and with this assurance came the promise that music education and musical literacy would continue to play a central role in the future of American musical culture.*

Today the trends are indisputably reversed. For many music listeners, recorded music is no longer the secondary but the primary form of their musical experience; no longer viewed as a reproductive apparatus, but as an independent and separate entity. Rather than containing the memory of a fleeting event, an aural photograph of a moment past, recorded sound dominates our universe and defines the present. Unlike the home piano of earlier times, it offers instant access to the uninitiated. In the age of consumerism, music is more often product than activity. Moreover, in a society as inundated with recorded sound as our own, whether it be atmospheric background to television drama, advertisements, airports or restaurants, the majority of musical experience is both involuntary and passive.

The appearance in the late twentieth century of a music audience the majority of whom do not read music, who have never heard a sound and identified it as corresponding to a mark on a paper, is a unique

*Virgil Thomson, "Processed Music," *New York Herald Tribune*, May 16, 1943.

phenomenon. And it poses unique challenges to both those who write about music and those who perform it. It also poses a new challenge, one that has been discussed much less but is crucial to the future of concert life in the next century, to the music listener himself.

The process of listening to music, listening to the music that has evolved in western civilization over the past millennium, is intrinsically tied to the process of memory. The grammar of such musical forms as the fugue and the sonata are dependent on aural recognition. In the fugue, the ear follows the transpositions and reappearances of the thematic subject against polyphonic activity. In the highly narrative sonata form—developed in the Classical era by Haydn and Mozart, transformed by Beethoven, and expanded in the great romantic symphonies up through Dvořák and Mahler—the demands on memory are even greater. The dramatic musical journey asks of its listener an active participation; the tensions and subsequent resolutions of the musical material are rendered meaningless without a sense of recognition—not necessarily conscious identification, but, as was perhaps best captured by Marcel Proust in his novels, a perceived comprehension of the musical language itself.

Discourse on music, by its very nature, is an act of translation. The means and methods for describing what one has heard have varied throughout history, ranging from the subjectively metaphoric to the objectively technical. In the nineteenth century, as musical amateurism and an urban middle-class grew,

music journals and music criticism flourished. E. T. A. Hoffmann's seminal review of Beethoven's Fifth Symphony in 1810, using both the objective and subjective approaches, set the example for future generations. While we are led through a detailed account of the musical action ("Immediately thereafter the strings play the F# minor chord, which is repeated four times, the winds alternating with the strings in one-measure units"), we are also treated to quintessentially romantic interpretations of the musical narrative: "Radiant beams shoot through the deep night of this region, and we become aware of gigantic shadows which, rocking back and forth, close in on us and destroy all within us except the pain of endless longing . . ." (In fact, Hoffmann's article was the first to use the word "romantic" to describe an expressive style of composition.) At the end of the century, Krehbiel's article on Dvorak similarly combines the two approaches in a language more appropriate to his time; the interpretive aesthetic, rather than being romantic, reflects the relevant social issues of turn-of-the-century America—race and national identity.

Arguments about music are assumed to elicit sounds in the mind of the reader. Art criticism sometimes uses photographs to illustrate, and thus give the reader a way of visualizing, the work under discussion; film and theater use a combination of photography and narrative summaries; literature affords direct quotes from the work in question, taking the subject of the discussion out of context, but, nevertheless,

bringing it into the present of the review's reader. The ability to offer a correspondingly objective musical example, as in Krehbiel's "New World" Symphony review, is not available to today's music critic writing for the general educated public.

And while in the above examples from the other arts there is the underlying assumption that the interested reader will have the opportunity to go to the art exhibit, view the film, see the play, or read the book if he so chooses, in the world of music the specific event that has been reviewed, with the exception of opera, is not likely to be repeated. The review persists as a written record of an ephemeral moment, an account that continues tradition in combining both objective and subjective description. But its "objective" function—that of articulating by means of language what has occurred musically—is altered by the advent and availability of recorded sound.

The demand for a writer to present a detailed narrative of a musical event is diminished not only by the absence of a common language with which to do so but also by the modern music consumer's ability to have access to what Thomson called a "processed" form of the work or performer in question. The demands on the musician and the listener have been altered as well. For while aural memory will always be central to a satisfying and meaningful musical experience, the need to pay attention is greatly weakened.

Imagine that you are a music lover in the day of Beethoven, living in a small city miles from Vienna.

Imagine that his latest symphony has recently been composed. After months of waiting, you finally receive a piano reduction of the new work by mail from the publisher, and excitedly sit at the piano with a friend; the two of you play through the four-hand version. The themes are strange, the rhythms difficult. You play slowly at first, trying to make sense of it all. You meet repeatedly in the coming weeks, the music becoming more familiar. Many months later, you hear that a performance of the symphony will take place in a nearby city. You and your friend make the four-hour journey by coach. You arrive in the concert hall tired but elated, and take your seats. The conductor appears, the symphony begins. You do not know when, or if, you will hear this work again. How do you listen?

The power of the experience is dependent upon your ability to pay attention; the afterlife of the experience is dependent on your memory; the two are intertwined. The intensity of the listening process under such circumstances is nearly unimaginable for the modern day concert-goer, for whom access and availability require no more effort than the flick of a switch.

Consider an alternate version of the story: the morning of the concert your city is hit by a violent blizzard. It is impossible to make the journey to the concert, and so you miss the performance of Beethoven's new symphony. And then you receive E. T. A. Hoffmann's account of it all. How do you read?

All this is not to encourage a wave of nostalgia for a lost past, something that the music world has wallowed in far too comfortably. (And for longer than one might think: in 1921, the music critic Paul Rosenfeld lamented, "a musty presence inhabits the American concert hall.") But the dramatic change in the way in which music is perceived and experienced necessarily has its effects on the relationships between performer and audience, critic and reader.

The function of a concert, itself, is tremendously altered once it becomes only one of several ways in which music can be heard. Whereas recordings began as replications of concerts, now the relation has become inverted: the recording business drives the concert world, audience members expect concerts to reproduce pristine recordings, performers strive to imitate rather than create, and there exists a large segment of music listeners who only rarely, if ever, enter a concert hall. While the excitement of live performance should stem directly from the spontaneous and ephemeral character of the moment—the essence of which can not be captured in another medium—performers find themselves competing not only with their contemporaries but with the literally immortal artists of past generations whose recordings outsell their own.

Criticism continues to serve descriptive, philosophical, and analytical functions, as well as increasingly vital educational ones. And in the Baudelairian sense, where there is art there will always be criticism;

for the making of art itself demands critical thought.*
But it is undeniable that newspaper reviews, like
much else in today's world, have taken on an increas-
ingly commercial function.†

This is in turn reflected in the amount of space
each discipline commands from its publishers. Music
reviews, far reduced in size from Dvořák's day, become
fodder for the difficult and hype-laden business of
selling new artists and new pieces to a public that is
increasingly hard to identify. As editorial positions of
power are inherited by young professionals belonging
to a generation that has received no musical education
whatsoever—a kind of educated elite that Thomson
did not foresee when he looked to the future—artists,
managers, and concert presenters watch in panic as
the journalistic space allotted for classical music
shrinks ever-smaller.

The music world is by nature conservative; the act

* ". . . all great poets naturally, inevitably become critics. I feel
sorry for poets guided by their instincts alone; I regard them
as incomplete. In the spiritual life of great poets, a crisis is
bound to occur that leads them to examine their art critically,
to seek the mysterious laws that guided them . . ." (from
"Richard Wagner and Tannhauser in Paris," *Baudelaire: Se-
lected Writings on Art and Literature*, P. E. Charvet [London:
Penguin, 1992]).

†At times, journalistic import today can exceed that of the
event itself. Publicity outweighs reality. In *Testaments Betrayed*,
Milan Kundera suggests that we may have moved into a new
sphere of existence in which journalism replaces culture.

of performing music from the past turns our glance backward. Conservatory training involves the transfer of legacies from one generation to the next; great performers teach young, aspiring artists, and musicians pride themselves on tracing their teachers' teachers back through decades and even centuries. When I was a student, one of these "games of telephone" for those of us studying with the Polish pianist Mieczyslaw Horszowski always gave us a thrill: Horszowski studied with Leschetizky, who studied with Czerny, who studied with Beethoven. This sense of a tangible past is, in some ways, a welcome anomaly in a culture so desperately interested only in itself. Yet it discourages the questioning of received notions and does not promote a meaningful relationship to the present American culture in which musicians must function.

As often happens with games of telephone, the most important information may be lost along the way. Classical musicians could learn much from the examples of their nineteenth-century heroes: the multifaceted careers of such individuals as Mendelssohn, Berlioz, Schumann, Liszt, and Dvorak reveal intellectual projects and engagement in their communities for which there is no room in the modern ideal of the successful globetrotting virtuoso, whose relationship to music is comparatively one-dimensional. The need for new definitions, new relations, new mandates for concert music is ignored in most conservatories; the contemporary world in which modern musicians must practice their art is too often viewed as no more

than a difficult, somewhat alien, marketplace of competition.

Dvorak's sojourn in America provoked a forum for issues vital to the American music scene at the turn of the century: arts funding (the National Conservatory of Music and American Opera Company were attempts at national institutions built by wealthy individuals); elitism (Dvořák attacked the practice of performing operas in foreign languages, something accessible only to "the upper classes"—the *American* Opera Company would reach everyone); arts education (the philanthropist Jeanette Thurber sponsored scholarships for minorities, women, and African-Americans—Dvořák argued for free education for all); race and identity (Dvořák's advocacy of African-American spirituals and Native American songs as the source material for the creation of American concert music); and the American vernacular (Krehbiel argued that until "the vernacular becomes the language of the performances and native talent provides both works and interpreters" concerts would remain relegated to the "exotic" in American life). These issues are no less relevant—nor, for that matter, any closer to resolution—as the century comes to an end.

* * *

A Crisis of Values

And yet, if the passions of today's public, remaining relatively lethargic over the dramatic crisis in national arts funding, have recently become engaged,

this has been provoked not by a particular issue or a piece of music but, rather, by a personality.

"Personality" has always played an exaggerated role in the American music scene. Audiences fell in love with performers before repertoire; the prize-winning pianist Van Cliburn led them to Tchaikowsky, Leonard Bernstein to Mahler, and so on. Because the superstar phenomenon was much in evidence in the postwar "golden age," managers today have continued the habits of an era long past with frequent announcements of the next "Horowitz" of the piano or "Heifetz" of the violin. No matter that the world itself has changed. These names of promise disappear quickly with the emergence of new names, while the public that follows the paths of these comet-like careers literally dies.

With neither the ability nor the interest to distinguish one musical interpretation from another, the appeal of hearing the next musical legend is not enough to get new listeners into the concert hall. And with so little attention spent on promoting the music itself rather than the transient names of performers, appealing to potential new listeners (who may be uninitiated but not unintelligent), or creating stimulating programs—the fare served up on American dinner menus has shown more inventive change in the last decade than that of its concert programs—there is absolutely no long-term educational investment in building a new audience.

The recent cause for crisis in the classical music world appeared from outside of the music world itself:

a personality bearing neither critical accolades nor prestigious management, but a commodity far more negotiable in turn-of-the-millennium America—a life story. A story of real suffering, but conveyed through an unreal medium; no one ever argued that *Shine* was a documentary film. A story of talent and private pressures resulting in early success and then breakdown; a story uncomfortably familiar to any music conservatory graduate, where each class witnesses the fall of talented young artists to unbearable psychological pressures—yet this story came with a Hollywood ending of triumph.

The appearance of the real David Helfgott in the real concert halls of America brought the classical music world to center stage for the first time in recent memory. Crowds thronged to the box offices; newspapers sent their critics to distant cities to cover the first recitals; "sold-out" banners went up and additional appearances were announced; the Academy Awards presented live classical music to a massive television audience; new readers turned eagerly to music reviews. All the past publicity successes of music presenters were dwarfed in comparison. Faced with this rare box office phenomenon, the music world squirmed awkwardly; suddenly the rest of the world was paying attention.

The phenomenon serves as a peculiar paradigm for many of the issues that plague America at this turn of the century—issues that reach far beyond the confines of the classical music scene. Immediately appar-

ent were the populist/elitist arguments that have informed this nation's history. Once music critics and professional musicians pronounced a negative verdict on Helfgott's performances, it became clear that this was not a case of the long-awaited savior, nor was it the hoped-for happy ending.*

The passion with which Helfgott fans denounced these professional views revealed deeper chasms in American culture. Accusations of "heartlessness" and "cruelty" brought into question the purpose of criticism. Standards of excellence were deemed irrelevant in the face of a moving personal story. For the *story* had so touched Americans that their entrance into the concert hall was an entrance into the celluloid world itself. In a reversal of the fantasy of Woody Allen's *The Purple Rose of Cairo*, people enthusiastically leaped into the last scene of a movie and believed it was reality.

The insistence of an artistic discipline on standards other than that of popular success has a way of looking downright un-American. With the arrival of David Helfgott, the seemingly aloof music world entered mainstream America with a vengeance of contemporary relevance. The obvious continuation of attention to "star personality" over "musical content" was not new. But the merger of real and unreal worlds, with a refusal to distinguish one from the

*See Anthony Tommasini, "For Audience at a Recital, the Shine Is Undiminished," *New York Times*, March 16, 1997.

other, speaks eloquently of a culture in which representation of life drowns out authentic life itself; in which the responsibility falls upon the individual to consciously draw borders that outwardly no longer exist.

Add to this the disappearance of boundaries between the private and the public (personal disclosures from Helfgott's wife were central to the public performance), hero-worship of the victim (suffering becomes identity), and sentimentality over informed thought (sympathy precludes judgement), and the concert hall becomes a new variation on the themes of American daytime television.

Psychological health has not been a prerequisite for successful concert careers: the iconoclastic, brilliant pianist Glenn Gould's sufferings and eccentricities have also attracted attention from the film industry, to give one well-known example. But in the past, the source of interest in such musicians was initiated by their artistic contribution. The Helfgott case was inverted.

In her controversial essay, "Discussing the Undiscussable," Arlene Croce raised the question of whether the choreographer Bill T. Jones had placed himself "out of the reach of criticism" by presenting terminally ill patients as performers in his piece about AIDS, *Still/Here*. In Jones's case, a deliberately confrontational decision was made by a proven artist to include terminally ill patients in his performance piece and for these patients *to appear as such*; they

were not asked to perform strenuous feats beyond their physical capabilities.

But with Helfgott, the intersection of art and illness was not intentional; it had been central to the marketing of the artist, was present in the consciousness of every spectator, but in no way could be viewed as a part of the conscious contribution of the artist. The pianist David Helfgott presented a uniquely disturbing and confused subject for evaluation. Never had the chasm between the dominant, popular market culture and that of a rarefied art form been brought into evidence so clearly.

When the dollar becomes an absolute value, is it possible any longer to call a box-office success a failure?

What happens to the function of art and critical commentary in a society that measures all by numbers?

* * *

The difficulty of art is that it cannot be measured. There are no yardsticks or timers that can adequately do the job. Many an artist has left the concert stage dejected, only to find a rave review the next morning; the reverse is equally true. This is not to say there are not standards within each artistic discipline. There are standards that act as measures, but they are neither fixed nor as easily defined as an athlete's speed and distance; the highest rewards that are offered, unlike gold, have no weight. Certainly, worldly success can gratify an artist: both acclaim and money make life more agreeable and raise one's self-esteem; they can

even divert one from deeper questions of self-evaluation, which have no definitive answer. But these questions, and their lack of answers, are central both to artistic existence and the appreciation of art. Much of life has its immeasurable aspects; but art is actually defined by them.

Popular discomfort with the function of artistic criticism, as witnessed in the Helfgott case, is a vivid example of the ongoing tension that exists between art and society in the American model of free-market capitalism that increasingly dominates the world. It may well be that it is exactly art's refusal to be measured by the number standard that controls the rest of culture that gives it a unique function. This is where the paths of "art" and "entertainment" diverge, and this is another area where contemporary America exhibits a great distaste for drawing boundaries.

America is a country founded on populist ideals. The notion of high art has persisted in Europe with little challenge because of a traditional link between cultural identity and the artistic legacy of a nation. But in America, identification comes with popular culture—the new world's gift to Europe. Americans did not have a tradition of high culture that felt native rather than imported, hence the concerns of Dvorak, Krehbiel, and others a hundred years ago. It was in the uncharted territory of popular culture that America invented a cultural identity.

Americans have made quite extraordinary contributions to the fields of art, literature, concert music,

dance, and theater, but these contributions have not
been absorbed into national consciousness with the
same level of recognition, have made few inroads into
American identity itself.* And as the American vari-
ants of movies, television and popular music have
grown to dominate the world market, the concern for
defining a distinctly American "high art" has lost its
urgency; the thirst for cultural identity is satisfied
elsewhere.

In the seventies and eighties, it became a common-
place for American artists to guiltily admit to a strange
envy of their counterparts in Eastern Europe. *Samiz-
dat* publications of censored literary works appeared
in translation and Americans discovered the writings
of Brodsky, Kundera, Havel, Konwicki. The clear op-
position between official art and dissident works im-
mediately gave art meaning and weight. The freedom
of the west left no room for opposition; without ten-
sion, art seemed relatively frivolous. Daily life under a
clearly repressive regime offered the conflicts out of
which one could make art. Western artists felt, in
comparison, self-obsessed, solopsistic, and, in relation
to their public, ignored. The torturous memoirs of

*Jazz, that great American invention, historically elicited
greater respect abroad than in its native country. Jazz musi-
cians today depend on concert fees from Europe and Japan to
supplement performances at home, which are usually in clubs
rather than concert halls, with correspondingly smaller rev-
enue.

Dmitri Shostakovich revealed a creative life of unbearable tension; yet the unhappy composer had only disdain for the western alternative, where, if he emigrated, he expected that his symphonies would be greeted with indifference.*

Judgments of success or failure in art cannot be surrendered to the marketplace. Certainly, arts organizations should strive to reach new audiences, to battle a culture only of privilege. But there is a kind of marginality far more difficult to define than that of underground theaters.

For art to stand in opposition to a monolithic government is a clear stance; but ours is not a country of visible borders. The threats to artistic integrity insinuate themselves into our society with greater subtlety; there is no equivalent to a searing review on the front page of *Pravda*, there is little opportunity for cultural martyrdom.

There is instead the daily struggle of economic survival, where a lack of subsidies creates ever greater dependence on box-office receipts and at the same time drives up the price of tickets. But most insidious are the hidden, yet directly related, threats to artistic survival: the artist who commands an audience of

*The gravity of musical criticism in the Soviet era is epitomized by the 1936 article in *Pravda* on Shostakovich's opera, "Lady Macbeth of Mtsensk Street." Issued after Stalin attended a performance of the work, it branded the young composer as an enemy of the people.

only a few holds no prophet status in America. The rule of numbers is a seductive one, and it replaces the role of critical thought in the minds of artists as well as audiences.

Financial success and fame become the blatant singular aims of creation; art the business of self-promotion. In the post-Warholian world, the adherence to any standard other than that of popular success becomes a mythical pretension viewed suspiciously by a cynical populace. In this construct, the tension between art and society collapses entirely.

It is easier to let fixed values, such as box-office returns and performance fees, be a gauge of one's work than the unanswerable, immeasurable challenges of artistic creation. And as the monotony of ubiquitous corporate chains makes unknown cities eerily familiar, the tyranny of majority rule taste moves us, paradoxically, toward a world of diminishing choice.

Art can be the last frontier of difference. Not by an explicitly political content, but by being "other." By rejecting the absolute value of numbers, by continuing to define itself by values of its own. That these values be subject to never-ending debate, challenge and critical commentary in terms that are idealistic rather than utilitarian—that the art itself set the rules of engagement—is vital to the questioning character of art.

The power of a Beethoven string quartet transcends, and by so doing, contradicts, the oppressive

materialism of our *fin-de-siècle* mall culture—just as it transcended and contradicted Metternich's Austria at the time it was composed.

"Is there a measure on earth? There is None," wrote the German poet Friedrich Hölderlin at the end of the eighteenth century. The lines come from a poem that inspired Heidegger's late essay, "Poetically Man Dwells":

> Full of merit, yet poetically, man
> Dwells on this earth.

It is in the balance between the material struggles on earth, and the upward glance toward something "other," that man distinguishes himself. A society that looks for the utility in such "upward glances" and finds none because of the measures brought to bear will surely be the poorer for confining itself to the limits of earthly riches. It is, perhaps, a romantic notion of art's function; but I know of none better for the times in which we live.

About the Editor

Maurice Berger is a Senior Fellow at the Vera List Center for Art and Politics of the New School for Social Research in New York. He has taught and lectured at such institutions as Hunter College, Yale University, the New York Institute for the Humanities of New York University, the DIA Center for the Arts, the Whitney Museum of American Art, the Whitney Independent Study Program, and the Institute of Contemporary Art, Boston. He has written catalog essays for the Solomon R. Guggenheim Museum, the Whitney Museum of American Art, the Philadelphia Museum of Art, the Yale University Art Gallery, the Grey Art Gallery, The Jewish Museum and other institutions as well as articles for journals and newspapers including *Art in America*, *Artforum*, *The Village Voice*, *October*, and *Afterimage*. He is the author of a number of books, including *Labyrinths: Robert Morris, Minimalism, And the 1960s* (Harper & Row, 1989),

How Art Becomes History (HarperCollins, 1992), and *White Lies: Race and the Myths of Whiteness* (Farrar, Straus & Giroux, 1998) as well as editor of *Modern Art and Society: A Social and Multicultural Reader* (HarperCollins, 1994) and co-editor of *Constructing Masculinity* (Routledge, 1995).

About the Contributors

Homi Bhabha is a professor at the University of Chicago.

Michael Brenson is a freelance critic and curator. He wrote on art for the *New York Times* from 1982 to 1991.

Arlene Croce is the dance critic for the *New Yorker*.

Jim Hoberman is a columnist for the *Village Voice*.

bell hooks is Distinguished Professor of English at the City University of New York, and author of many books including *Art on My Mind* and *Teaching to Transgress*.

Wayne Koestenbaum is a professor of English at the City University of New York's Graduate School.

Richard Martin is a curator at the Costume Institute of the Metropolitan Museum of Art.

Joyce Carol Oates is the Roger S. Berlind Professor in the Humanities at Princeton University.

Sarah Rothenberg is a pianist, a senior fellow at the Vera List Center for Art and Politics of the New School, and artistic director of Da Camera of Houston.